PETER GREENAWAY

Artworks 63-98

PAUL MELIA & ALAN WOODS

MANCHESTER UNIVERSITY PRESS

CORNERHOUSE

CONTENTS

PREFACE

Painting and draughtsmanship have been central to Peter Greenaway's practice for the last thirty-five years. They have been essential parts of a speculative investigation carried on across a wide front along with the production of films, operas and novels. The varied nature of Greenaway's artistic output has obvious attractions to a multi-disciplinary arts centre such as Cornerhouse, and we are proud to present this retrospective exhibition of Greenaway's artwork. This publication, the exhibition, the accompanying film programme and symposium all bear witness to Cornerhouse's dedication to presenting important work to new audiences.

We are delighted that Peter Greenaway responded so positively to our suggestion that we stage this exhibition and thank him for his comments and suggestions on the selection, as well as for agreeing to lend a significant number of items. Eliza Poklewski Koziell – keeper of the artist's collection – supported the project with great enthusiasm, liaised between ourselves and Peter Greenaway, identified the location of various works, arranged their photography, and dealt with a continuous stream of questions. Without her support this project would have been much less ambitious. We also thank Annabel Radermacher, the artist's personal assistant, both for her support and for liaising between the artist and ourselves at various stages during the project.

Paul Melia first approached me with a proposal for this exhibition over two years ago and we are grateful to him and his co-curator,

Alan Woods, both for selecting works with great care and for their advice on, and involvement with, all aspects of the exhibition and its tour. It has been a pleasure to work with them.

We are pleased to have collaborated with Manchester University Press on this publication and thank especially Matthew Frost, Lauren McAllister, Gemma Marren and David Rodgers. Our thanks also to Alan Ward for his creative design, as well as to Staffordshire University for a grant towards the cost of colour plates.

I would also like to record my appreciation of the efforts made by my colleagues at Cornerhouse in bringing this major project to fruition, in particular: Kate Jesson, Exhibitions Organiser; Vicky Charnock, Galleries Education Officer; and Siobhán Ward, Exhibitions Assistant. I also thank Pat Fisher of Talbot Rice Gallery, Edinburgh, for her support of the exhibition tour.

Finally, we wish to express our deep gratitude to Manchester Airport whose early and generous support of this project was crucial. Manchester Airport has a distinguished record as a sponsor and we are delighted to be associated with them once again.

Paul Bayley
Director of Exhibitions, Cornerhouse

FRAMES *of* REFERENCE

Paul Melia

A BEGINNING

Born in 1942, Greenaway was educated at Forest School, a public school in Walthamstow. In September 1960 he turned down the offer of a place at Cambridge University and enrolled at Walthamstow School of Art for a four-year course leading to the National Diploma in Design (NDD). The teaching system at Walthamstow was, as with many art schools at that time, organised around a study of perspective and anatomy. Painting was understood as including the acquisition of a visual language to enable artists to record their perceptions of the world as accurately as possible and as a form of craftsmanship appropriate to such a requirement. Typical diploma paintings represented urban landscapes and domestic interiors in a style that mixed Impressionism with Social Realism – as interpreted by the Camden Town Group and the Euston Road School. With few exceptions, art schools were immune to Continental or North American Modernism. Following his intermediate examination, Greenaway elected to specialise in easel and mural painting, producing a mural on the School's central staircase towards the end of his course.

From the beginning, however, Greenaway had little affinity with the School's conception of art practice: 'I was at art school and didn't really know what I was doing... I was not interested in observational work or being a dispassionate documenter, or even a passionate one.'[1] Furthermore, his attempts to inform his practice with his interest in literature and history were firmly discouraged: 'I was repeatedly told my paintings were too literary... I was told... to avoid those rooms in the Tate Gallery that had red flock wallpaper and exhibited the Victorians... Art schools are so successful at breaking your confidence.'[2]

Greenaway's increasing dissatisfaction with what he perceived to be a narrow conception of painting – one that did not facilitate an imaginative engagement on his part and presumably, therefore, gave rise to works characterised by cliché – would not have been mollified by the examples of the new painting, Modernist abstraction, then being exhibited in London galleries and reproduced in art magazines. A concern with subject-matter and a concern with the surface of the work were perceived by Kenneth Noland and other Modernist abstractionists to be mutually exclusive. According to the theories expounded by the influential American art critic Clement Greenberg, the history of modern painting involved the gradual elimination of all illusions of three dimensions accompanied by an increasing emphasis on the flatness of the picture plane. The surface of the painting – its flatness, its colour, its edge – was, in Modernist circles during the late fifties and early sixties, understood to be painting's only legitimate subject, and references to anything beyond the picture plane were, in the words of Greenberg, 'to be avoided like the plague'. Painting was to be addressed to eyesight alone.

Between February and March of 1963, Greenaway saw the first solo exhibition of work by the American artist R. B. Kitaj, *Pictures with Commentary: Pictures without Commentary*, at the London gallery Marlborough Fine Art. Kitaj had graduated from the Royal College of Art the previous summer and many critics perceived his work, along with that of his fellow students (Derek Boshier, Pauline Boty,

David Hockney and Peter Phillips), not only as attempting to reconcile the lessons of Modernism with a personal commitment to the figure and imagery drawn from the urban environment, but also as a development of Pop art. In his 1963 show, Kitaj exhibited work that contained a multiplicity of discrete images, abstract forms as well as figurative motifs, painted in a variety of styles or collaged from pre-existing sources, including magazine and newspaper photographs (figure 1). The wide range of source material, considered by many at this time as being outside the domain of painting itself, was supplemented by newspaper articles, labels and prose – either handwritten or printed – collaged directly on to the painting surface. The close relationship between painting and writing was further emphasised by Kitaj in the catalogue published to accompany the show. Kitaj's commentaries on his works included quotations from a diverse range of European authors as well as *bibliographies* for individual paintings. In a review of the exhibition **The Times** noted, 'Kitaj's work stands for a firm reaction against any appraisal of a picture by its formal qualities alone... he demands the longer, more complicated experience which engages the whole intelligence.'[3]

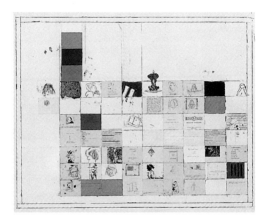

figure 1
R. B. Kitaj, *Specimen Musings of a Democrat* 1961
oil on canvas, 102 x 127.5 cm. Collection of Colin St John Wilson.

Kitaj's conception of painting came as a revelation to Greenaway. When asked in 1990 about the impact this exhibition had had upon him, Greenaway commented, 'I suddenly saw this body of work that legitimised all I had hopes of one day doing. Kitaj legitimised text; he legitimised arcane and elitist information; he drew and painted as many as ten different ways on the same canvas; he threw ideas around like confetti, ideas that were both pure painterliness and direct Warburg quotation [that is, **Journal of the Warburg and Courtauld Institutes**]. There was unashamed political passion and extravagantly bold sexual imagery. His ideas were international, far

from English timidity and English jokiness, and that timid and jokey English pop-art.... I envied him and still do... he is a painter in whom I have not a single misgiving and I could not say that about any film-maker.'[4]

In addition to legitimising his belief that painting could be as difficult and as multi-layered as the works of modern poetry and literature he admired, Greenaway was also shown a technique – collage – through which his interests could be addressed. Collage emphasises arrangement; it is an aesthetic of conjoining that allows both the production of a vivid, flat surface – necessary at this time if one's work was to count as, or at least look, modern – while at the same time enabling a vivid subject to be addressed. Having rejected narrative structures derived from literature, collage represented a distinctly modern technique with which he could structure his subject matter.

It would appear that Greenaway immediately began to work out the consequences of Kitaj's example in practice. For **Nativity Star** (plate 1), a rationalists' account for the occurrence of the star, Greenaway appropriated elements from late mediaeval or early Renaissance altar-pieces – **The Wilton Diptych**, c. 1395, in London's National Gallery, for instance. A 'modern' look was assured since his central motif – a painted artefact – was already flat. Furthermore, the idea of basing his work around altar-pieces probably appealed to him since their typically bi- or tri-partite structure provided self-contained panels which would lend a conformity and uniformity to his diverse range of subject matter and materials – constellations, figure painting, text, collage. The range of media and techniques employed is further evidence of Greenaway's debt to Kitaj, explicitly acknowledged by the inclusion of a collaged typescript on the right 'panel'.

The presence of numerals also indicates another non-narrative means of organising his subject-matter (the Virgin is of less significance than the Christ child but of more importance than the wise man) but also suggests the activity of 'painting by numbers' – especially since so many areas of the work include outline drawings of some complexity. Perhaps there is the suggestion that the ideal of the artist upon which Greenaway's training was based is spurious: a closely observed subject and a professional-looking finish do not necessarily signify something difficult or accomplished.

By the time he had completed his NDD in the summer of 1964, Greenaway – aged 22 – had come to the decision that his future lay with the film industry: since 1959 he had been pursuing his interest in European cinema, focusing on the films of Antonioni, Bergman, Godard, Pasolini and Resnais. After leaving Walthamstow School of Art, Greenaway bought himself a clockwork 16 mm Bolex camera and applied to the Royal College of Art film school. Surprisingly, he was not one of the twelve out of four hundred applicants accepted and, instead, turned his hand to film journalism and odd jobs in the cutting rooms of Soho. During the mid-sixties he developed his interest in literature – particularly the *nouveau roman* and Latin American fiction, specifically the work of Alain Robbe-Grillet and Jorge Luis Borges – and began writing stories. One distinctive feature of Greenaway's interests at this time is the demonstration of his commitment to the practical and theoretical tenets of European, rather than North American, Modernism. In 1965 Greenaway entered the employment of the Central Office of Information (COI), where he remained for some fifteen years, eventually becoming an editor and then director. Despite his full-time employment at the COI, Greenaway continued to develop his practice as a fine artist, addressing a range of issues which he also explored in his writings and the short films he began to produce in earnest in 1966. [5]

THE FLATBED PICTURE PLANE

Although the 'altar-piece' in **Nativity Star** is depicted as parallel to the picture plane – emphasising the surface, the flatness of the work – the painting as a whole retains an illusion of recession since the altar-piece is situated in a (nocturnal) landscape. In subsequent works, Greenaway was to reject any hint of illusionism and employed a variety of strategies or devices which emphasised the flatness of the support. To make sense of Greenaway's emphasis upon surface, we need to look not to Greenberg's account of the development of modern painting but to an alternative interpretation advanced by the critic Leo Steinberg. [6] In his discussion of the 'combines' of the American artist Robert Rauschenberg – assemblages which included painted and printed images – Steinberg borrowed from printmaking the phrase 'flatbed picture plane' in order to draw attention to the horizontality of the support, comparing Rauschenberg's combines to table-tops or pin-boards. 'No longer the analogue of a visual experience but of operational processes', Steinberg argued that the flatbed was to be understood as an analogue of the experience of modernity. Equally important to Steinberg's notion of the flatbed picture is the idea of the de-centred art object, based not on composition but on the principle of heterogeneity and spread, on diffusion rather than centredness. Steinberg also argued that the horizontality of the flatbed picture plane suggested a corresponding horizontality in the image-field. It declares the field of vision to be no longer parallel to the vertical of the upright body of the spectator – even though works may be hung on a wall – but parallel to the ground or sky.

The idea of the flatbed is useful for framing a discussion of Greenaway's **Computer Vocabulary** (plate 2) – a record of 'operational processes' – and his series of stellarscapes (plates 3–5) which, like **Computer Vocabulary**, declare the field of vision to be horizontal. Both engage with ideas and imagery concerning cybernetics and outer space that were explored in art in a series of exhibitions organised by the Independent Group (IG) during the 1950s, particularly **This is Tomorrow**, shown at the Whitechapel Art Gallery, London, in 1956. Representative of their interests in this respect is Lawrence Alloway's word list (derived from **Galaxy Science Fiction** magazine) in the catalogue published to accompany a 1956 solo exhibition of another IG member, Magda Cordell: 'solar, delta, galactic, amorphous, ulterior, fused, far out, viscous, skinned,

visceral, variable, flux, nebular, iridescence, hyperspace, free-fall...'. '[It] is a cluttered log and carries the prints of aliens, meteorites and galactic dust,' Cordell wrote of another of her 1956 paintings. [7] The IG were responsible for expanding the domain of art practice to include an eclectic range of ideas which included, as David Robbins has written, 'Shannon's information theory, Weiner's cybernetics, semiotics via Dorfles and Cherry, Huizinga's theory of play, early McLuhan, game theory, and topology'. [8] These interests were also pursued and developed by artists from an earlier generation – Victor Vasarely, for example – as well as by younger artists such as Roy Ascott, who became prominent during the sixties as a leading proponent of a cybernetic art. Such was the increase in the number of artists engaged with science and technology that the Institute of Contemporary Arts (ICA) organised a survey exhibition in 1968, *Cybernetic Serendipity*. Greenaway visited this exhibition and although he found many works both tedious and clichéd he was interested in the assemblages of Mary Bauermeister, with whose work he was familiar, having seen her first solo exhibition at the Stedlijk Museum, Amsterdam, in 1961 (figure 2). A one-time student of mathematics, astronomy and electronic music, Bauermeister employed a rational system to organise her disparate material, including stellar imagery, on to a grid only to contradict this system with illogical, absurd or chance elements. [9]

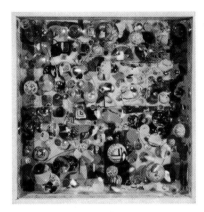

figure 2
Mary Bauermeister, *Four Quarters* 1964-65
mixed media, 76.2 x 76.2 x 17.1 cm.
Collection of the Albright-Knox Art Gallery, gift of Seymour H. Knox.

Each brushstroke in *Computer Vocabulary* has been numbered with Letraset and presented in columns as though measured and catalogued by a machine or computer. In presenting a personal and temporal event that has been made impersonal and a-temporal, the piece explores that threshold zone between gesture and cipher, expression and signal, thereby evoking the notion of human identity either being pushed to the limits of recognition or being subsumed by technology. At first glance, the series of stellarscapes may appear to celebrate the powers of human reason and technological progress by employing different means to map and organise the universe. However, a closer examination reveals that one work (plate 3) utilises a tonal system to organise the stars (suggesting that the stars have been recorded at regular intervals between night and dawn), another employs a numerical system to count the infinite number of stars (plate 4), a third uses a grid to map the *mist* of stars (plate 5). What the series actually provides one with is an experience of order that is, in fact, spurious: an attempt to order the universe with an obsessional neatness and exactitude indicative of insane obstinacy. The absurdism, scepticism and seriousness evident in both *Computer Vocabulary* and the stellarscapes can be understood as questioning both rationality and the utopian claims made for technological progress on which the optimism of the post-war period was founded. Perhaps it is precisely this quality which Greenaway both detected and admired in the work of Bauermeister. As Jan van der Marck has written of her assemblages, 'Mixing the visual with the literary, they can be read as well as seen. The tectonic concerns most sculpture is preoccupied with are raised to the level of parody in an almost slapstick permutation. The mind is allowed to run rampant, but on a circulatory course.' [10]

The tendencies exhibited by Greenaway's work can also be seen in the artistic culture of Sol LeWitt and other American Minimalists. As Rosalind Krauss has observed, 'For LeWitt's generation a false and pious rationality was seen uniformly as the enemy of art... For this generation the mode of expression became the deadpan, the fixed stare, the uninflected repetitious speech.' [11] Also important to that culture was an indifference towards those issues which invited

the parading of commitment and belief, as well as a tendency towards the cultivation of public euphemism and irony, characteristics which inform Greenaway's identity as an artist. As Greenaway has noted, 'What is also constant – then and now – is the irony, irony as tolerance, as non-dogma... that there are no longer any certainties (if indeed there ever were) and surely no single meanings – except to the very simple-minded who endearingly want things kept straightforward and clear-cut.' [12]

The notion of the flatbed picture plane resembling a table-top or a pin-board is useful for a discussion of Greenaway's collages from the early seventies. In 'The Chinese Wallet' series (plates 14–17), for example, fragments from a wide range of sources are embedded in or scattered over the supports of individual works: torn newspapers, old posters, pages from academic books and manuals, cartoons, advertisements, scientific diagrams, wallpaper, newspaper articles and photographs, all orchestrated by patches, strokes and lines of oil paint. (Greenaway has

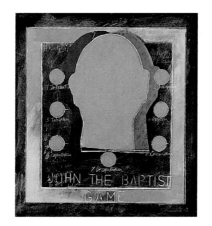

figure 3
John the Baptist Game 1993
acrylic on card. Destroyed by the artist.

compared the pink and red bands of paint in this series to both rubber bands and the ribbons of a Chinese wallet.[13]) Following Steinberg, we can view the fragmentation and lack of focus of these works, the compensatory dynamism and flow, as providing an analogue to the experience of modern life, particularly modern urban life. The injunction to depict the here-and-now has been made many times by many artists during the modern period, but Greenaway's attention to the experience of the fugitive, the ephemeral and the contingent does not ally him to the practice of British or American Pop artists. Rather, his work has affinities with *Nouveaux Réalisme* – those works by Raymond Hains and Jacques de la Villeglé from the fifties and sixties based on layers of torn posters and handbills from the advertising hoardings on unused public surfaces in French towns and cities. Indeed, in an untitled and

undated (and perhaps even unfinished) movie shown in biographies 20 and 22–3 of his 1980 film *The Falls*, Greenaway explicitly allied his interests with theirs: shots of torn advertisements, hand bills and posters are edited with footage of urban street life and political protest. A further point of difference between Greenaway's concerns and those of certain English and American Pop artists is that while those of the latter revolved around the abundance and replacement of consumer goods, Greenaway's are predicated on the retention and preservation of 'abject' material. The horizontal plane of Steinberg's flatbed is here allied with a 'base materialism' in contrast to the sublimatory function of the vertical plane in traditional painting. [14]

These incongruous fragments invite a process of free association on the part of the spectator, a process that can give rise to dream-like effects. It is precisely these effects which conventional cinema, characterised by narrative continuity, can rarely achieve and to which Greenaway draws our attention by titling one piece *If Only Film Could Do the Same* (plate 11). In his artworks and films of this time, Greenaway does not treat the city as an ideal of unity and order – as espoused by Modernist architects such as Le Corbusier – but as the dwelling place of the modern unconscious. His practice therefore invites comparison with that of the Situationists as well as with the work of certain Surrealists – Louis Aragon and André Breton, for example. In addition to dream-like effects, we may also experience the base materialism of these 'dismembered' texts and images, collaged together in unfamiliar and even disquieting ways, as evoking the 'uncanny'.

Another aspect of the flatbed picture plane explored by Greenaway is the gaming board, a scaled-down map of social events organised with rules and regulations. Greenaway's gaming boards establish a

physically continuous relationship with the viewer – vision is not dissociated from touch – yet, simultaneously, a sense of a strange landscape separated from continuous reality is evoked. *Gaming Board* (plate 10) is composed of fragments of wood hinged together to produce an uneven surface which makes play difficult: an ordinary object has been rendered disquieting by a puzzling deformation. The spectator is warned against 'playing' *John the Baptist Game* (figure 3): composed of seven stages, it culminates in a decapitation. It is to the 'chess sets' and boxes of the Fluxus Group and to the gaming boards of Surrealism – Alberto Giacometti's *No More Play* (1933), for example – that one has to look to find parallels with Greenaway's concerns.

A final instance of the flatbed picture plane explored by Greenaway is the map. But before considering the numerous map-pieces produced during the late seventies, we need to attend to the strategies he employed to depict the landscape.

MAPS AND MAPPING

I have always been fascinated by the particular excitements aroused by a sense of place, the distinction of a particular genius loci. *This is true if the place, space or location is indeed a real one but it is certainly also true if the location has been invented in words, in a painting or in the cinema.* [15]

In a series of landscapes from the late sixties and seventies Greenaway continued to declare the field of vision as horizontal, although in these works the field of vision now slides groundward rather than skyward as it did in his stellarscapes. Having decided to produce landscapes, however, he was faced with a series of issues which had led ambitious artists of the early sixties to exclude landscape as a possible subject for painting. Landscape was seen by them as too much the individual achievement of an older generation of artists – Henry Moore, Graham Sutherland, the painters of the St Ives School – whose cultural status was now part of what had to be confronted. Certainly the older artists' commitment to a pre-

industrial, an essentially de-politicised Romantic ideal of landscape was in stark contrast to the younger artists' engagement with an industrial, urban culture. But there were also other issues at stake: given the problems concerning the nature of meaning and representation bequeathed by that strand of post-war art in which the American artists Jasper Johns and Robert Rauschenberg are central figures, the work of any ambitious young artist that drew uncritically upon the tradition of English landscape art would have appeared clichéd. Personal experience, empathy, quasi-magical feelings aroused by a place or location, spontaneity – all triggers of artistic production for the older generation – could now only be treated as conventionalised or codified by a generation inhibited by an extreme self-consciousness about the whole notion of the 'expressive'. When artists did turn to landscape towards the end of the sixties, they drew upon forms of representation derived from the sciences rather than personal experience: diagrammatic representations and tabulated data of the sort to be found in geography books, atlases and maps. Drawing on such a vocabulary – based on an analytic rather than a retinal approach to the land – the artist was no longer obliged to exhibit a quasi-spiritual commitment or even a subjective response to nature (even though many, including Richard Long, elected to do so).

Like many artists of his generation, Greenaway drew upon geological diagrams (plate 7) and topographical charts (plate 8). It was material and procedures from the discipline of cartography, including aerial views (figure 4), which provided him with a particularly rich resource, however. For one untitled 'public' art work, Greenaway used a large-scale Ordnance Survey map on which he marked off an area of two square kilometres and attempted – at night – to bury ball bearings at the intersections of the map's grid lines. The work remained unfinished because – according to Greenaway – those points of land corresponding to the points of intersection were usually occupied by trees, buildings or some other obstacle. However, even in its unfinished state, this work can be said to offer the spectator an object for contemplation even though that object is imaginary. Related to this project is *Landscape Section* (plate 9), with ball bearings arranged in rows and columns at regular

intervals, which, with its use of wax and sand to represent the land in relief, also draws on topography and has similarities to the work of Mark Boyle.

In other works which derive from Greenaway's interest in cartography, the activity of the spectator is conceived not simply as a form of contemplation, but also as a process of inquiry undertaken in a spirit of irony and scepticism. The ninety-two maps produced by Greenaway during the summer of 1978 embrace numerous cartographical conventions (and a fair share of invented ones as well), the result of an absurdist search for a map in every available surface: for example, the hides of piebald cows, a bramble leaf mined by a gall-wasp grub (plate 25), a piece of used sandpaper (plate 30), the cat scratchings on a kitchen door, the splashing of bird-lime on the back of an envelope, and the rivers of white that are formed on a page of text when spaces in consecutive lines of type are adjacent to one another. These maps are not simply the products of a hobbyist of the absurd. They raise a number of issues, such as: what are maps; what is their function; what is the difference between a map and a picture; how does one 'read' a map; how are maps meant to be used; what is the relationship of the map to the landscape it represents? Among the precedents for Greenaway's absurdism and questioning is Borges's short story *Of Exactitude in Science* (1933-34), about an empire in which 'the craft of Cartography attained such Perfection that the Map of a Single Province covered the space of an entire city, and the Map of the Empire itself an entire Province. In the course of Time, these Extensive maps were found somehow wanting, and so the College of Cartographers evolved a Map of the Empire that was of the same Scale as the Empire and that coincided with it point for point...' [16]

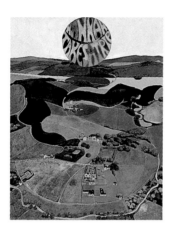

figure 4
Hannah Takes a Trip to Wardour 1969
oil on hardboard, 61 x 46.5. Collection of the artist.

The absurdism present in Greenaway's work has as its focus the commonsense assumption that material reality can be unproblematically described by cartographic conventions. The fallacy of this assumption is that direct access to material reality outside systems of representation is not possible: the world cannot be disclosed to consciousness directly. The conventions of any representational system, including those of cartography, are *social* – not 'objective' – in character. There is an important sense in which the map becomes, or *is*, the territory. This point is made towards the beginning of section three by the narrator of Greenaway's 1978 film of these maps – *A Walk Through H:* 'Perhaps the country only existed in its maps, in which case the traveller created the territory as he walked through it.' [17]

Once again, irony is an important part of Greenaway's scepticism: his concerns here are not dissimilar to those exhibited in his stellarscapes (plates 3–5). In his artworks from the seventies, eighties and nineties – discussed in the next section – Greenaway continued to examine the relationship between material reality and other types of visual and linguistic systems which common sense tells us can unproblematically describe that reality. Both in his artworks and in his films, Greenaway does not stop at scepticism, however, but goes on to consider possible worlds or conceptual spaces more fantastic than those of the country of H.

Other devices to depict landscape are employed in two other films by Greenaway from the seventies. *Windows* (1975) presents a series of shots of the countryside as seen through sash windows. The windows, complete with mullions, resemble a grid and our view of the idyllic landscape is therefore highly organised and 'disciplined'. The use of the window here is not dissimilar to the use of the

perspective grid in Greenaway's 1982 film, *The Draughtsman's Contract*. For *Vertical Features Remake* (1978) – which includes shots of numerous pieces of his artwork (see, for example, plate 18) – Greenaway drew upon cartography and arithmetic progressions in order to represent the land. The first of the four films within *Vertical Features Remake* consists of footage of vertical features (trees, posts, poles, for example) found, in a manner that brings to mind the the imaginary work linked to *Landscape Section*, within the square kilometre bounded by the grid lines 170 to 180 and 390 to 400 on sheet 161 of the First Series of the 1:50,000 issue of the Ordnance Survey map of Great Britain. Shots of the vertical features are arranged so that each successive section of film is one frame longer than its predecessor. In the second film within *Vertical Features*, eleven sections of film, each composed of eleven images, are edited so that each successive section is eleven frames longer than the preceding one. By such means Greenaway was able to produce an elegy to the landscape in the full confidence that he was doing so using a non-Romantic, distinctly contemporary vocabulary.

GRIDS AND TABLES

Given Greenaway's interest in the flatbed picture plane, it should be unsurprising that the one device he came to favour above all was the grid, even using it to display his own artwork (see figure 5). The grid is, as Krauss has argued, emblematic of the modernist ambition within the visual arts: 'one of the most modernist things about it is its capacity to serve as a paradigm or model for the antidevelopmental, the antinarrative, the antihistorical'. [18] The grid has been used by artists in a number of ways during the twentieth

figure 5
Photograph of the exhibition *Watching Water*
Palazzo Fortuny, Venice, 1993.

century and Krauss characterises their use of it as either centripetal (the mapping of the space inside the frame of the work of art on to itself) or centrifugal (the work of art is presented as a fragment of the world beyond the frame). Krauss cites certain works by Mondrian as an instance of the centripetal tendency: 'black lines forming the grid are never allowed actually to reach the outer margins of the work, and this cesura between the outer limits of the grid and the outer limits of the painting forces us to read the one as completely contained within the other'. [19] An instance of the centrifugal use of the grid is certain works by Warhol in which a single image is repeated numerous times as in, for example, *210 Coca-Cola Bottles* or *Marilyn x 100*, both from 1962. Greenaway's use of the grid, from his early stellarscapes to work considered in this section, is centrifugal since into the pictorial discipline of the grid, rigorously bounded by the sides and right-angles of a rectangle, he inserts and organises a kind of human content: horsemen (plates 50–2), postcards, corpses (plate 47), an agricultural bestiary (figure 6), Prospero's books (figure 11), the contents of imaginary suitcases, as well as quotations from paintings by John Constable and isobars from weather forecasts (plate 42). In addition to imagery he also introduces text. Only occasionally can Greenaway's use of the grid be described as centripetal, as in *Pages from 'A Framed Life'* (plates 44–5) where the modules of the grid are occupied by coloured paint.

The centrifugal or beyond-the-frame attitude supports a range of ways of using the grid. At the more abstract end of the spectrum we find passages of disembodied decoration – brush and pencil work – juxtaposed with elements taken from sign systems capable of expansion – alphabets or numbers, for instance (see plates 43 & 47). In such works it is not unusual to find the grid cropped by the edge

of the painting, emphasising the centrifugal tendency (see, for example, plate 47). Less abstractly, we find this tendency enables Greenaway to provide himself with an index of his own practice, wherein ideas are identified and then considered in relation to one another, thus enabling him to clarify what he is doing and consider why and whether he should continue. Of *55 Men on Horseback – Five by Eleven* (plate 50) and *Weighing Horses* (plate 52), for example, Greenaway has written, 'After completing the filming of *A Zed and Two Noughts* I took a short holiday... I came across fifty-five horses...they were a series, fifty-five optimistic but modest mid-eighteenth century gouaches, more instruction than excellent aesthetic. They became the subject for a new project – *55 Men on Horseback* – that has dogged the imagination ever since, and has still not seen the light of day as a novel or as a film... The possibilities of structuring these fifty-five stories and the horses within them... is a continual preoccupation. Here are two painted considerations full of symbolic incident, paced according to jumps and falls, love-making and V for venalities.' [20]

Here the relations between the elements are catalogued and arranged in a manner that is not so much intuitive as logical, not so much implied as seen. The grid – with its co-ordinates and overall regularity – can be understood here as a symbol of design, of the higher and finer workings of the human mind, as a modern variant of a rational, classical order of measure and proportion. It is used both to produce and to sustain order. In other beyond-the-frame works, however, Greenaway employs the grid to question what constitutes 'order' and 'meaning'.

What, for example, are we to make of the series of collages collectively entitled *The Falls* (plates 34–9) which, on a film animator's grid, heap together pictures, diagrams, text and collaged elements depicting airmen and aviators, pilots and navigators, birds and birdmen, feathers and food, seagulls and space travel, waterfalls and free-fall? Juxtaposing such incongruous elements with the regularity of the grid may be humorous, but it is also disconcerting. Other instances of incongruous 'cataloguing' occur in *Old Water* (plate 93) and in the child's zoo shown in *A Zed and Two Noughts*, in which spiders and flies have been placed together simply on the grounds that they share the same colour.

Something more monstrous is achieved in *Blackbird Singing in the Dead of Night* (plate 49) – in which the repeated image of the bird was produced with a stencil, Greenaway's first use of a template. About this painting Greenaway has written, 'A memory of birds falling into the fire-grate is not enough to explain this picture, nor can it be wholly ascribed to the McCartney lyric, or to "Bye Bye Blackbird" or the nursery rhyme "Sing a Song of Sixpence" with its "four-and-twenty blackbirds baked in a pie," that details the matrimonial difficulties of George I, George II and George III (whose entire progeny totalled seventeen, not twenty-four). I remember that Piranesi and Blake engraved fireplaces as hack work for publishers selling architectural handbooks. Piranesi drew the fireplace like a picture-surround, but he left out the fire; some of these fireplaces are left unfilled in honour of his reluctance to draw flames. One of the conundrums of *A Zed and Two Noughts* was the unanswerable anti-Darwinian riddle: "Is a zebra a black horse with white stripes, or a white horse with black stripes?"... Another question: how do black and white stripes camouflage a zebra in a brown and green environment? Can the same question be asked of a black blackbird with a bright yellow beak? In acknowledgement of these natural history problems, the fireplaces are surrounded by the standard army-issue camouflaging.' [21]

Greenaway's use of language here resembles the ramblings of a compulsive or the speech of an aphasic. Indeed, the multiplicity of unstable, idiosyncratic associations that the grid fails to contain brings to mind Michel Foucault's description of the inability of a table top to contain an aphasic's ordering of differently coloured skeins of wool: 'Within this simple space in which all things are normally arranged and given names, the aphasic will create a multiplicity of tiny, fragmented regions in which nameless resemblances agglutinate things into unconnected islets... But no sooner have they been adumbrated than all these groupings dissolve again, for the field of identity that sustains them, however limited it may be, is still too wide not to be unstable; and so the sick mind

continues to infinity creating groups then dispersing them again, heaping up diverse similarities, destroying those that seem clearest, splitting up things that are identical, superimposing different criteria, frenziedly beginning all over again...'[22]

Our disorientation becomes even stronger when presented with Greenaway's *Epsilon's Agricultural Bestiary* (figure 6). The painting presents a meticulous taxonomy of domestic animals, ordered according to their 'cheapness, ability to feed, aspiration, wish-fulfilment and the correspondence of the number's own shape to the shape and mien of the animal... thus the number 2, among other reasons, being all beak, is a chicken.'[23] Although most of the criteria listed can individually be used to categorise animals, they are here made to mingle promiscuously without condensing into any sort of overarching 'meta-criteria'. Despite the work's modular structure, no grid of identities, similarities or analogies actually exists which can legitimise all these different and similar things. Taxonomies such as this are *heterotopian* and, as Foucault points out in his discussion of Borges's Chinese encyclopaedia, are 'disturbing, probably because they secretly undermine language, because they make it impossible to name this *and* that.... because they destroy "syntax" in advance, and not only the syntax with which we construct sentences but also that less apparent syntax which causes words and things (next to and also opposite one another) to "hold together"'.[24]

figure 6
Epsilon's Agricultural Bestiary 1990
mixed media on card, 107 x 81 cm. Whereabouts unknown.

figure 7
The Cloud and 100 Umbrellas from the exhibition
100 Objects to Represent the World
Hofburg Palace, Vienna, 1992.

Heterotopias remind us that direct access to material reality outside systems of representation is not possible: cultural codes allow us to observe not so much nature as nature which has been exposed to our method of questioning, classifying and ordering. Once again, Greenaway is parodying the assumption that the world can be completely represented in language. These issues are developed in his films, in which a gross proliferation of lists, taxonomies and statistics is called into being – like the list-making activity of Brother Juniper in Thornton Wilder's novel **The Bridge of San Luis Rey** (1927) – by forces which not only lie outside our comprehension but which also wreak havoc with our representations of nature: the 'Violent Unknown Event' (**The Falls**) and 'acts of God' (**Act of God**, **A Zed and Two Noughts**). In these films, the representatives of order – lists, taxonomies and statistics – are, like the grid in **Epsilon's Agricultural Bestiary**, reduced to mere bric-a-brac, reminding us that our representations of the world and the world itself are not continuous. Here Greenaway denounces the Enlightenment's faith – which, for many, has survived the twentieth century's catalogue of disasters – in the possibility of both progress and a total, finite and rational domain of knowledge. In its place he offers us an epistomological nihilism: any act of understanding or representation is necessarily provisional, contingent, temporary, relative, incomplete, and will be marked by accident, chance and randomness.

It is instructive at this point to briefly examine Greenaway's curatorial work. Since 1992 a number of museums have invited him to present an exhibition using items drawn from their permanent collections. As might be expected, Greenaway became fascinated by the codes and systems employed by modern museums to identify and classify objects: 'It is sometimes possible to come across artefacts where attempts to identify and classify have almost obliterated the object itself. Catalogue numbers, identification numbers, addendums and corrections supplied by a string of archivists have sometimes smothered an object under labels and tags – indeed have sometimes almost drowned an artefact in its own classifications.' [25] As might also be expected, he became fascinated by the ideology that governs the ways in which museums have, since the nineteenth century, both selected objects for display and related them to one another. As Eugenio Donato observes, 'The set of objects the *Museum* displays is sustained only by the fiction that they somehow constitute a coherent representational universe. The fiction is that a repeated metonymic displacement of fragment for totality, object to label, series of objects to series of labels, can still produce a representation which is somehow adequate to a nonlinguistic universe. Such a fiction is the result of an uncritical belief in the notion that ordering and classifying... can produce a representational understanding of the world.' [26] Indeed, for an exhibition at Vienna's Academy of Fine Art, Greenaway mocked the 'uncritical belief' and the 'metonymic displacement' at the heart of the museum's ideology by choosing to represent the world with a mere one hundred objects (figure 7). He used a fountain-pen to illustrate the irony of his ambition: '[it] is a machine that can represent all machinery; it is made of metal and plastic which could be said to represent the whole of metallurgy industry from drawing-pins to battleships, and the whole plastics industry from the intra-uterine device to inflatables. It has a clip for attaching it to my inside jacket pocket and thus acknowledges the clothing industry. It is designed to write, thus representing all literature, *belles lettres* and journalism. It has the name Parker inscribed on its lid, revealing the presence of words, designer-significance, advertising, identity. No object in the exhibition in Vienna was as small as a fountain-pen, but a similar process of association was always at work.' [27]

For other exhibitions he has organised, Greenaway's epistomological nihilism has manifested itself as an historical nihilism. For example, his 1992 exhibition at the Glynn Vivian Art Gallery, Swansea (figure 8), was 'rather grandly called SOME ORGANISING PRINCIPLES' and modestly hoped to 'excite in a way that perhaps the 17th century antiquarian museums or the Wunderkammern excited – that is before the precise 18th century museum approach regimented all knowledge into fixed and separate categories. It makes comparisons of like with like, crossing functions and periods and geographical considerations to compare similarities and likenesses.' Furthermore, the exhibition could be 're-envisaged from a completely different perspective: it also has the endearing possibility of allowing itself to be added to in the manner of the 19th century list-makers. SOME MORE ORGANISING PRINCIPLES or indeed, EVEN MORE ORGANISING PRINCIPLES, would easily and legitimately further the excitements of research, collection and collation.' [28] From this perspective origins are erased, differences disappear, indifferent objects are arranged according to speculation, and retrospective exhibitions of an artist's work – based on the assumption that the meaning of a work originates in the biography of the artist – are rendered valueless and uninstructive.

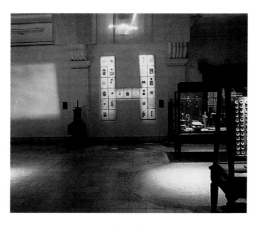

figure 8
Photograph of the exhibition *Some Organising Principles*
Glynn Vivian Art Gallery, Swansea, 1993.

NOTES

I would like to thank Paul Dewhirst – to whom this essay is dedicated – for his helpful comments on the manuscript, my colleagues at Staffordshire University for their support, Pedro Guijarro Fuentes for his patience, and members of the Peter Greenaway electronic mailing list – particularly Alan Andres, William van Wert and Andrew Wilson – for answering my queries and for a lively and informative discussion covering many aspects of Greenaway's *oeuvre*.

[1] Peter Greenaway, 'My Great Advantage over Veronese is that I can make the People Move', *Art Newspaper* n. 9, v. 2, June 1991, pp. 10–12. The advice of one of his lecturers to 'draw what you can see and not what you know' is mocked by Greenaway in his 1981 film *The Draughtsman's Contract*.

[2] Ibid.

[3] 'An Eagerly Awaited First Exhibition', *The Times* 7 February 1963, p. 16.

[4] Peter Greenaway, 'My Great Advantage over Veronese is that I can make the People Move', *Art Newspaper* n. 9, v. 2, June 1991, pp. 10–12.

[5] The bibliography at the end of this book provides a list of films directed by Greenaway.

[6] See the title essay in his *Other Criteria* Oxford University Press, New York, 1972.

[7] Lawrence Alloway, *Magda Cordell: Paintings* (ex. cat.) Hanover Gallery, London, 1956, unpaginated. Magda Cordell's description was published in *Statements: a Review of British Abstract Art in 1956* ICA, London, 1957. Both quotations are taken from David Robbins ed. *The Independent Group: Postwar Britain and the Aesthetics of Plenty* (ex. cat.) MIT Press, London, 1990, p. 62.

[8] David Robbins, 'The Independent Group: Forerunners of Postmodernism?' in Robbins ed. (1990), p. 239.

[9] Given that Greenaway dates his interest in the work of John Cage to 1959 it is perhaps worth noting that for the score of *Atlas Eclipticalis* (1961–2) Cage placed transparent sheets on the pages of *Eclipticalis*, an astronomical atlas, and traced the positions of stars. One of the forty-one manuscript pages of this score is dedicated to Bauermeister.

[10] See, 'Assemblage, Pop and *Nouveau Réalisme*, 1957–67' in Ethel Moore ed. *Contemporary Art 1942–72: Collection of the Albright-Knox Art Gallery* Praeger Publishers, New York, 1972. Greenaway's 1988 film, *Drowning by Numbers*, begins with a girl counting and naming one hundred stars. In his commentary on the film Greenaway speaks of the girl's activity as mocking 'Science and Mathematics and Counting itself... [she] counts a star a second – if she lived a biblical lifespan she could not count more than two thousand million – a snip': *see* Peter Greenaway, *Fear of Drowning* Dis Voir, Paris, 1989, pp. 19 and 21.

[11] Rosalind Krauss, *The Originality of the Avant-Garde and other Modernist Myths* MIT Press, London, 1985, p. 258.

[12] See Liz Reddish ed. *The Early Films of Peter Greenaway* British Film Institute, London, *c.* 1992, pp. 2–3.

[13] See Leo Steinmetz and Peter Greenaway *The World of Peter Greenaway*, Charles Tuttle Co., Boston, Mass., 1995, p. 8.

[14] For a detailed discussion of this issue see Rosalind Krauss, *Cindy Sherman 1975–1993* Rizzoli, New York, 1993, pp. 93–7.

[15] Peter Greenaway in Dominique Astrid Lévy and Simon Studer eds *The Stairs* (ex. cat.), Merrell Holberton, London, 1994, p. 79.

[16] Lewis Carroll imagined much the same thing in *Sylvie and Bruno* 1889.

[17] For a detailed discussion of the map being the territory, see D. Turnbull, *Maps are Territories* Deakin University Press, Victoria (Australia), 1989. An amusing consideration of the consequences of equating the territory with the map is given in Gilles Tiberghien, *Land Art* Art Data, London, 1993, p. 171, which also contains a discussion of the use of maps by other contemporary artists.

[18] Krauss (1985), p. 22.

[19] Krauss (1985), p. 21.

[20] Steinmetz and Greenaway (1995), pp. 52–3.

[21] Steinmetz and Greenaway (1995), p. 50.

[22] Michel Foucault *The Order of Things: An Archaeology of the Human Sciences* Tavistock Publications, London, 1985, p. xviii.

[23] Peter Greenaway *Papers – Papiers* Dis Voir, Paris, 1990, p. 112.

[24] Foucault (1985), p. xviii.

[25] Peter Greenaway in Alison Lloyd ed. *Peter Greenaway: Some Organising Principles* (ex. cat.) Glynn Vivian Art Gallery, Swansea, 1993, Section 7.

[26] Eugenio Donato, 'The Museum's Furnace: Notes toward a Contextual Reading of *Bouvard and Pécuchet*' in Josué Harari ed. *Textual Strategies: Perspectives in Post-structuralist Criticism* Methuen & Co., London, 1980, p. 223.

[27] Peter Greenaway in Lévy and Studer eds (1994), pp. 15–16.

[28] Peter Greenaway in Lloyd ed. (1993), Section 1.

FIELDS *of* PLAY

Alan Woods

Everything in the world exists in order to be put into a frame. [Mallarmé, adapted.]

A catalogue is a frame of sorts. There could also be a catalogue of frames. Such a catalogue would imply two possible histories. (Perhaps, rather, two approaches to the same history.) Firstly, a chronology of frames as objects – ornate, discreet, plain, gilded, painted, wooden, metal, whatever – revealing a history of paintings as both precious and formal objects; of the social status of painting, and also of the nature of the changing relations between painting and wall, picture space and real space. Secondly, a conceptual history of 'the frame': abstracted, defined as a series of ratios and possibilities, as sets of proportions which define and shape, as well as contain, pictures – but also theatrical productions, and films, and television programmes, and photographs. (Even books: the book is a minimalist sculpture of bound ratios before it is anything else.) The emphasis here might shift towards an interest in what is within the frame, and how: landscape or portrait format, the golden section, symmetry and asymmetry in composition.

This conceptual history of ratios, which is a history running through Greenaway's *oeuvre*, may be explored in a variety of ways. Within a frame, in a painting containing a grid of smaller frames – rectangles of particular proportions. Or within a book, each page of which carries a number of frames. Or within a cinema or television frame;

the new technology allows reworkings of the old device or game, familiar throughout the history of painting, of frames within frames, pictures within pictures. This was first explored by Greenaway in work for television, beginning with *A TV Dante*, and later within cinema, in *Prospero's Books* and *The Pillow Book*. Or, indeed, 'within' (though what is inside, what is outside such a project?) an installation throughout a city, as in the ongoing *Stairs* project. A hundred framing devices throughout Geneva defined and isolated location, using a variety of frame ratios and formats; in Munich, the history of cinema was reduced to a countdown of years and a sequence of cinema and television screen ratios, projected on to buildings. This 'catalogue of frames', then, can take the form of a book, or a painting, or a film, or an exhibition. Working across media, what might the catalogue suggest about frames and framing in painting, in television, in cinema?

In the history of painting, frames are at once conceptually crucial and physically substantial in their negotiation of the boundaries, physical and interpretative, between what they contain and what they exclude, in their proposal of the relations between what is shown and our proper response to its showing. To exhibit paintings without frames is to propose a very particular, and at one point radical, relation between the image (or the painting as a physical object) and the wall.

In television, the frame is a part of an apparatus. The edges of the screen, with their curious curvings and refractions and occasional hints that something, somehow is being lost at these edges, discourage a creative use of the edge as a compositional device.

This apparatus-frame, moreover, becomes visibly at odds with what it shows whenever a widescreen film is shown: sometimes the broadcaster's acceptance of an original cinematic ratio leaves top and bottom blank; sometimes there is a switch away from the original ratio after the credit sequence. Most often, we are shown a mutilated version as if the film had, all along, been made with television in mind; and as if film were, essentially, nothing but story – story, and the actors, framed anyhow.

And in cinema the frame is only where the dark begins and ends. There is darkness, filled with a sound which, increasingly in contemporary cinemas, dominates the invisible space; and there is a visible space which is a matter of light alone and has three kinds of frame. First, the specific frame of each frame of film, the original frame of film making; second, the frame of the ratio as established, more or less accurately, by the screen of this specific cinema and its machinery; and third, the edges of the film as it is, moment to moment, present in projection: uncertain, never quite displaying or matching the precise ratios of celluloid or of screen.

...careful composition of a picture into the corners of a [cinema] frame and right to the very edges is still not dependable when projected. Exact symmetries are not to be relied upon. Tolerances must be permitted. Hence the concept of the floating edge. Take your pick of a variable floating edge from the catalogue. Note (1990) to **Frame Catalogue** (1989), plate 43.

How often cinema considers this basic condition of cinema, from avant-garde demonstrations of its basic physical components (Hollis Frampton) through gags around projection and illusion (Buster Keaton, *Hellzapoppin'*, Godard, Woody Allen) to narratives of projection, scenes set in cinemas and projection booths, and the interest within documentary and thriller genres in what kind of evidence, and what level of detail, might lurk within an individual frame. Cinema begins with accumulating individual frames, and setting them in motion; here there is a retreat from cinema back to individual frames. And always there is what is missing, there is always the gap between two frames, the fragment between two fragments. (There is no more acute, concise or disconcerting example of the gaps between image and reality, seeing and knowing, witnessing and understanding, than the famous footage of Kennedy's assassination. The way the violence bursts into the footage, independent of the intention or understanding of the cameraman, can be compared with the organising conceit of *The Draughtsman's Contract*.)

Imagine a frame to be something which draws your attention to everything outside itself, everything it excludes.

+ / X: *a motif*

X marks the (a) spot.

X is a windmill waiting to happen.

X is a sign of illiteracy.
This may not imply visual illiteracy, just as verbal literacy does not imply visual literacy.
It is a signature for those who cannot write their name, and, since it is a genuine signature, there are as many different Xs as there are illiterates.

Football:
X, as well as a signature, is (in football pools) a plea for no publicity, for anonymity.

X is where the ball might be, within a photograph taken deliberately to be unclear, not easily read at a glance, composed to contradict what we know about the composition of images (or selected because it has the virtue of accidentally, unintentionally, combining all these vices): X, here, is the viewer's decisive intervention into an indecisive moment. (A 1990 commentary on a 1972 collage, **Red Footballers** (plate 12), suggests that 'the supplied irony here was not to find the missing ball, of which there are possibly a marked dozen, but to spot the footballer, who is not flying in urgent and frantic action but sedately composed for his footballing photograph'.)

Cricket:
In **Drowning by Numbers**, in **Night Cricket** (figure 9), and in **Crossing Smut** (a collage which places a drawn windmill beside a close-up of Smut with black tape crosses on his face and chest), Smut's body is used to document cricketing injuries. Not injuries he himself has suffered, but injuries from the history of cricket. First his body, and then the collection of Polaroids taken of his (almost naked) body, constitute a catalogue, a history of the violence done when a hard ball hits flesh. Smut becomes a very English St Sebastian, struck by the deliveries of

figure 9
Night Cricket 1988
mixed media on card, 81 x 112. Private collection.

outrageous fortune, a saint martyred at the wicket. (A different father might have marked Smut's body with the wounds made by arrows in four hundred years of Sebastian pictures.)

X is 'a crossroads in Oriental perspective'. (Or: 'a crossroads signpost in contorted perspective'.)

X is erasure by typewriter.

X is the twenty-fourth letter of the alphabet, notoriously difficult for compilers of alphabetical lists (like Beta in **A Zed and Two Noughts**). And the third letter of 'text'.

X is the number ten in Roman numerals, still used for the dating, in credits, of films and television programmes.

X/✚ is where two lines intersect (and the beginning, perhaps, of an alternative grid, a new frame of reference).

✚ (within Western perspective) is where any vertical feature (a goalpost, perhaps) interacts with any horizontal feature (perhaps the crossbar at the other end of the pitch) so that, although legibly distinct – even distant – from each other in depicted space, on the flat surface of the paper a cross is formed.

An artist committed to categorisations, catalogues, escapes classification.

Valéry, writing to his brother, thinking aloud around his essay on Leonardo, wrote that he had reached the point at which he could 'ask whether this deductive centre of things, the mind, has not reached a high level of complexity simply so as to order things, combine the elements of its perception'; he was beginning to study 'the imagination as an instrument of common measurement, and the imaginative faculty as in itself a measurer of the link it automatically creates between the most diverse things'. This link is common to art and science: 'if one notices in a virgin, natural forest, a row of trees in a straight line, the idea of human intervention arises. One feels a *mind* has been there, the more so insofar as the row continues in length and regularity.' (**Collected Works** VIII, Routledge, London, 1972, pp. 405, 404.)

Which suggests a question: what manner of *chaos*, of disorder, of irregularity, noticed in a virgin forest, would also suggest the idea of human intervention? (And what would make it noticeable?)

If only Film could Do the Same... the title of a work in oil and collage (1972) plate 11.

One consequence of working across a wide variety of media, and indeed across totally different arts and disciplines, is that 'languages' (a dangerous metaphor) can be discussed outside themselves (through things they cannot do) as well as purely self-reflexively. Painting can be explored and analysed through film. Cinema can be examined through painting or installation. Opera can be presented as a novel. The central concerns and habits of thought (and, sometimes, characters) remain throughout, but as they move from text to image to opera to exhibition the different arts and media shadow and illuminate each other: the very movement is a critical movement, self-aware and aware of difference, and the possibilities of difference.

Aware, also, of the inevitability of bleedings across boundaries, across the floating edges which are both sharp enough to cut and subject to erasure, to arbitrary or chance rearrangements. Bleedings, and exports and imports: the carrying over of the concerns of Renaissance painting into cinema, say; or theatrical spectacle (and spectators) into literature; or narrative progression into the grid, that supremely non-linear system of lines, in which everything is always present, available, without a before or after.

Nor are there hierarchies (painting over film, film over painting). And the preference, expressed in a thousand interviews, for painting over film has to be balanced against the consideration that the artist expressing that preference has shown a consistent commitment to the making of films, and is, as a consequence, best known as a film maker. His history paintings, as it were, are his films.

But, because the central concerns and habits of thought (and often stories) remain throughout the *oeuvre*, the boundaries, not between different media but between discrete works of art, are broken. There is, for example, what might be called a **Drowning by Numbers** project, which is still continuing – though one might prefer to say that there is a 'death by water' project, details of which can be found throughout, but which comes to the forefront of particular works – **Drowning by Numbers**, and **Death in the Seine**, but also in the Icarus exhibition in Barcelona, **Flying over Water**, Icarus being a famous death by water. (Though Icarus is also an important part of the 'flying' project, an important strand of **The Falls**. And so on.) Within these overlapping projects, each piece (whether feature film or collage) confirms and modifies the rest; there is endless, and often farcical, cross-referencing. (And occasional contradictions, within the biographical details given at various times regarding Cissie Colpitts, for example.) Nor do these projects move towards a

conclusion, as a sequence of novels might. The effect is closer to soap opera: each episode tightly structured, but the whole open-ended, uncontainable, with the wider narrative of its shape a matter of external factors. (Finance, ratings, the availability of actors, and so on. In Greenaway's case, which cities fund which projects, which films can be financed, what computer equipment becomes available, which opera houses and museums invite him to work in which buildings. And so on.)

There is often, then, a radical and intriguing instability of reference. A reference to an imaginable but unrealised work in a collaged text can become, with the passing of time, a reference to a completed work; imagination is replaced by memory. A minor, perhaps unnoticed, detail can become retrospectively significant. For example, the passing interest in the inking of flesh in *A Zed and Two Noughts* (Beta stamping the twins) takes on a new significance with the release of *The Pillow Book* – a film made many years later, but first conceived, as *Twenty-six Facts about Flesh and Ink*, in 1984, the same year as work began on *A Zed and Two Noughts*. This is common to any *oeuvre*, but what is unusual is the extent to which the relation between any individual piece and the *oeuvre* is uncertain, fluid, insecure; how self-contained is any piece, how permeable is the frame around it? The drawings and paintings filmed in *A Walk Through H* (plates 23–30, figure 10) are merely an extreme example of this mutability and multiplicity.

It is an *oeuvre*, in any case, built up out of paradox, out of clashing and contradictory 'excitements' (a favourite word of Greenaway's). One might say each individual work, small or large, has two ambitions: to refer to nothing outside itself, and to refer to everything that is in the world.
(And one might argue: that is what any work of art does anyway, and cannot help but do.)
(And, further: the intended or *articulated* references are always *only an example* of what is actually referenced, or brought into play.)

Many of the works on paper might be considered in terms of:
the sketch;
the note to oneself;
the preparation;
the afterthought;
the pointing towards:- the idea as an idea for something (else) while still a thing (itself).

And also:
a history, linearity made spatial.
The script, necessarily in advance of the filming, is covered with emendations, made, perhaps, in the very process of filming; and is then, perhaps, incorporated into a collage, after filming is completed.
Often a long time afterwards.

In all these categories, the (semi-) isolation, or framing, of the piece involves a distancing, a move towards self-representation: the sketch, the pages of script are transformed (since we, as viewers, can only use them as we use works of art) into ideas of themselves. Paint that attempts to be nothing else but paint on a canvas can still become, within a particular critical climate, a kind of symbol of itself, or rather of the paintness of paint. Similarly, the idea of the sketch, of the visible workings of the artist's mind before our very eyes – related also to the late nineteenth and twentieth century fascination with the incomplete and fragmentary, from the cult of Leonardo's *Notebooks* to Duchamp's notes for the *Large Glass*, and to notions of the autograph and the artistic relic – becomes a part of the wider subject.

The ambience of play is by nature unstable. At any moment 'ordinary life' can prevail once again. The geographical limitation of play is even more striking than its temporal limitation. Any game takes place within the contours of its spatial domain.
[Guy Debord, *On the Passage of a few Persons through a rather Brief Period of Time* (film soundtrack, 1959)]

There is a (very) early painting of 1963. It is not a successful picture, but it is a fascinating one, because everything is already there. It contains all the elements that will later find an articulate voice: text in relation to image, the list, (very) short stories, art history, and collage, both as literal pasting and as an attitude towards the picture surface and how material might be composed, combined upon it. And a playing field.

The playing field is a kind of frame, or series of frames, with its marking out of boundaries both within the pitch and, crucially, between the players and the spectators, the performers and the audience. It is a marking out of territory, perhaps the only map we have invented that allows, indeed insists upon, a scale of 1:1. The laws of perspective ensure that normally we can never see it, either as players or spectators, in its purest form, which is the diagram: the way it is if we make a sketch to explain the game and the rules of the game to someone, or the way it is on the coach's blackboard, a permanent outline around a script – a storyboard – of circles, crosses, arrows, commentaries and erasures. The form of this diagram, which is pure and universal, and the form of the individual playing field are identical. Television coverage of important matches sets great store by the use, generally as a framing device before and after the match and at the start and end of each half or quarter, of the aerial view of the pitch (and stadium) – the only view in which the laws of perspective allow a view approximate to the purity of the diagram. All maps are aerial views, converted into symbols; but here the aerial view displays something that is already diagrammatic.

Games and sports are used by Greenaway in a way that invites at the very least a questioning of the relationship between arts and games. How are their various forms of playfulness, of carving out distinct spaces that are somehow distinct from 'real life', related? How do their formal structures compare? What are the dealings and misunderstandings between the players/artists and the viewers/spectators?

*(A deeper question, more particular to Greenaway, is posed throughout the **Drowning by Numbers** 'project' – how do art and games anticipate, ward off, make sense of, death? Or, even, lead to, structure death – Greenaway works at an angle which often cuts across the line of the classic English detective story – itself a game, or puzzle – in which murder, or a series of murders, is characteristically structured by literature (quotation), by nursery rhymes, by game playing. The setting is often, as Greenaway's settings are often, a version of English pastoral.)*

More generally, the relations criss-crossing between the playing field, the game, the rules of the game, the action performed by the players within this privileged space, and the viewing of it by the spectators, might be compared with the equally complex and fluid interrelations between text and image, image and audience. (Compared whilst assuming difference, distance, divergence: 'parallelism and drift [are] the very motion of metaphor' (James Wood).)

One set of rules allows an infinite series of games.

One story (or allegorical text) allows an infinite variety of illustrations, all dealing with the same subject and its restraints. In both cases, the text (or some version, or memory, of the text) is deduced by viewers from the sight of bodies (or representations of bodies). In both cases, the text – or our variable sense of the text – is a commentary on what is seen as well as a cause; it brings into focus what it has brought into being. The originating text is not physically present at all, but it is behind each action carried out or shown; it is embodied and internalised as an organising principle.

Twenty-two players and three officials, all speaking different languages, could certainly manage to play a game of football. Painting was once seen as a 'natural' language, and although we are now reluctant to believe this, our ability – within certain shared cultural

assumptions – to 'read' images, 'foreign' images, without anything easily comparable to translation – an ability which also facilitated the international marketing of silent films – remains intriguing, although bafflement before and misinterpretation of strange games and obscure paintings are, as one would expect, frequent.

We should also question the too easy, the seemingly obvious, assumption that the text, the set of rules, *originates*. An entire tradition of representations of the Annunciation, of the Crucifixion, could – did – evolve primarily through the matching and conceiving of images against and in terms of other images. Catholicism seeks to be visually persuasive in advance of theology, indeed of literacy. Nor do games evolve – or, rather, originate through creationist acts of will – with action straightforwardly following on from the establishment and circulation of a rule book. We learn games by joining in. Greenaway's games – Hangman's Cricket, Handicap Catch, Sheep and Tides, Bees in the Trees ('a variant on musical chairs... best played with funeral music') – are exceptional partly because their rules are established in advance of their performance. Inevitably so, as they are games within and for a film (**Drowning by Numbers**), the way the drawings for **The Draughtsman's Contract** are drawings within and for a film – neither are self-supporting. And cinema, of course, allows image and text to operate simultaneously. In **Drowning by Numbers** Smut's voice-over offers the rules of the game as we view an instance of it. And yet the baroque complexity of these games should remind us also of the singular games of childhood, established for a particular situation and place and then forgotten, their rules arbitrary, elaborate and subject to whimsical changes, established by the dominant personality as a part of the wider game of power over friends and enemies and ultimately enforced, in the absence of an official, by assertion or by violence, or the threat of violence. The rule as a speech act. (Compare the torture 'games' in **The Cook, the Thief, his Wife and her Lover**, improvised by Spica – pronounced 'Speaker'.) And, also, children (and parents) are accustomed to approximations of established games, to local rules improvised and necessitated by circumstance. Consider the single wicket chalked on to a wall, or consisting of a

tree; or the negotiable dimensions, the floating edges, of the goals established by two jackets in the park. The boundaries of genre can be equally free-floating. Perhaps the great difference between sport and art is that art operates fruitfully through the ambiguities inherent in casual games and play, but unthinkable in professional sport (although differences, often national, in interpretation of the rules remain fascinating). In sport, the field of play generates richness out of restriction, absolute divisions and decisions. (Consider also the taboos and rules around the proper relations between spectators and players, between the theatre of dreams and its audience. There is also an intriguing area of overlap and conflict between the rules of the game established or maintained by its organising bodies and the rule of the law of the land.) Artistic fields of play – like the systems, grids, and lists of Greenaway's classifications – are leaky, inclusive, subject to modification and reappraisal; their self-reference draws attention to their inevitable failure to be self-contained. Everything is (potentially) considered for inclusion; everything flows through.

The game, then – the individual game, not 'the game of football' but *'this* game of football' – is both the domain of the physical, the intuitive, the embodied and the once and once only, and – simultaneously and paradoxically – the iconic, the repetitive, the recognisable, the familiar, the constant-in-change.
As with play, so with painting.

THE MAP BECOMES THE TERRITORY

The eye is not a camera, and the differences between seeing and seeing what the camera has done are most poignant in the persistent failure of film to give a proper account of painting. It is a failure which begins, of course, with frames and framing: the camera puts a frame around the painting, distancing it, reducing it, or frames a succession of details, transforming a single, static image, a sense of which surrounds any concentration on any detail of the whole, into a sequence of fragments, a narrative, controlled by the film maker

rather than the viewer (or painter). How often we are shown some tiny detail first of all, and only then the composition in which it hides. And, of course, all the physical properties of the painting are lost, made over into the curious insubstantialities of broadcast or projected light; so texture becomes the illusion and trace of texture, scale becomes dependent solely on the use of apparatus, on the size of the television screen or the architecture of the viewing room.

All of these violations are reimagined in *A Walk Through H*. Since the film maker is also the artist, his domination of the paintings through film involves a realisation of what they lack, of what he has in mind for them. The paintings can only encourage our eyes to move through them in a particular way, but that way can be enforced by film. Film can determine which painting we see when and for how long, and add a narrative over that journey. The tiny scale of the map-like pictures may suggest imaginative journeys over large stretches of land; the film registers the miniature at the scale of the cinema screen (surrounds us with a detail at once smaller than an address label and too big to take in a glance) and, with the absurdist and disorientating literalism which is one of Greenaway's most distinctive and consistent devices, offers up the map as the landscape, the journey of the eye through the journey of the camera through the map as the journey of the hero through the landscape. There is no terrain outside the symbol; the picture-like maps (which, within the narrative, are not unchanging: they fade as they are used) become notes towards a supreme fiction of landscape.

One of the maps is a football field (figure 10).
A football field shown from above, diagrammatic, covered, 'invaded', by windmills/crosses.

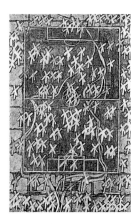

figure 10
A Walk Through H: The Football Field 1978
mixed media on paper, approx. 26 x 15. Collection of Kent Alessandro.

The map becomes the territory; the script becomes the film.

Literally, on occasion: in several of the earlier films, the script is what we see (and hear read out) on screen, film cutting across reading as it cuts across looking at pictures. (In *Vertical Features Remake* we also see strips of film: the strips of film we are about to see/not see – about to *see through*, as projected film.)

The entire history of Western painting could be written in terms of the inexhaustible relations between text and image. Image as illustration, as translation; image embracing textual prestige and origin, image asserting its independence and equality of status in relation to text, image in flight from text. Image delighting in text as image, as content, as a physical reality in the world, available to be cut up and pasted down in a collage, or painted like anything else in the visual field. (Although language remains language when painted; the word remains a word in both motif and painting, recontextualised but not *represented*.) Text as calligraphy. Text as caption to image.

Each imaginable – traditional, modernist, Orientalist – opposition and coupling of text and

image can be found flickering and paradoxical within Greenaway's *oeuvre*. One relation between text and image, however, is peculiar to Greenaway: the particular relation of script to image.

By exhibiting the entire script of **Drowning by Numbers** – a script turned into a diary of film making, covered with annotations and stained by accidents and weather, and by consistently using the pages of scripts as the basis of collages, Greenaway joins the modernist tradition of text as image, contrasting handwriting with typewritten and printed text, legibility with illegibility, what is approved with what is erased (or present under erasure, still intriguing, visible as discarded or forbidden), reading with looking. He modifies the linear into the spatial, giving us words which the eye does not leave behind, but has always present before it.

Because these are pages from scripts, however, there is an additional, and specific element: the language, besides being itself an image, besides 'conjuring up' images (if that is what language does), is a set of instructions for the creation of images. (At our time of viewing, these instructions may or may not have been more or less accurately followed, and we may or may not have seen the resulting film; and there may or may not be, indeed, an image from that film pasted on to the script; but I am concerned here with the instruction itself.) The script orders images and actions; it requires real things to be placed and real bodies to perform in real spaces. Not simply so, certainly, and in many different ways, with many different balances between documentation and fiction: the naming of a place in a script can mean either (or, at different times, both) the visiting of the place named (if, like Rome, it exists) or the creation or recreation of that place on set. And there are areas where, it is understood, the instruction means exactly what it says ('he takes off his clothes') and areas where it doesn't ('they have sex'; 'she kills him'). (This difference is explored in **Death in the Seine**, which on a couple of occasions includes footage of an actress acting (or ceasing to act) as herself, voluntarily or involuntarily ceasing to play dead. It is central to the conception of **The Baby of Mâcon**. It is tempting to say that painting cannot do this, but there are pictures by Lucian Freud and Paula Rego that play on an uneasy, and comparable, fit between the model in the studio and the figure in the painting.) Still, language in a script is a means to an end: words point towards images, bring images into being. Words become flesh, then celluloid.

(And there are no storyboards in advance of these images. The paintings offer maybe ghosts of storyboards, empty grids borrowed from cartoons, storyboards perhaps for abstract films – where the story is the movement of paint in two dimensions: water and pigment. Watching paint dry: a modernist narrative. (And watching dry paint decay.) Nothing here that could be built, or handed to a cameraman. No composition within these frames, certainly none that could be recreated. These

spaces could be – have been – animated, entered into as backgrounds in a computer mix. But the drawings and paintings, always ideas, are never commands. Commands are left to scripts – and to speech, the improvisions ordered on set, exploring the properties of properties.)

As a reference point, always Duchamp, who returned to art (against, in the teeth of, almost every theory and gesture of modernism) the text, the idea, the anecdote, the eye, the (sexual) body, the (dead) body, geometry – and also perspective. Duchamp, in other words, by abandoning painting, gave back to art all the traditional concerns of painting, of, indeed, history painting, even of allegory.

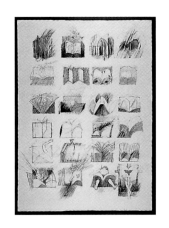

figure 11
Prospero's Books: A Catalogue 1989
pencil on card, 112 x 81 cm. Collection of the artist.

The space of allegory and the space of collage share many qualities. Both are spaces of connections, structured by thought rather than vision, with heady and often curious mixes. Allegory's almost pedantic dependence on text appears remote from the random and oblique strategies we associate most readily with collage, whether dadaist bite and absurdity, surrealist free association or a post-modern indifference to origin. But that very dependence on text, with linguistic structures and relations translated into a complex syntax of allegorical figures and properties, offers many bizarre contortions all the stranger for the sweet reason, often commonplace and platitudinous, of their origin. And the images are also all the stranger for being shoehorned into a picture-space compromised by perspective, a system of spatial relations comically ill equipped to handle such material. (Where a poet might easily mention in passing the cunning of a fox in an account of the death of Achilles, Rubens must put his fox killing an eagle somewhere in physical relation to his dying hero. Here is Achilles – and here, just ahead of him, one step down, are the creatures.) Moreover, the uses of collage space with which we are most familiar by no means define the limits of its possibilities; the natural tendency of the scrapbook – collage is a folk art – is to bring together texts, images, scraps and souvenirs which connect naturally, at the level of ideas or sentiment. If Greenaway mocks organising principles, he never abandons them, and there is enough genuine regard for collecting, enough delight in demonstrable connections, however playful or fictional, to restore to his collage spaces systems of association deeply rooted in Western painting. An enabling link was Kitaj, not always literally a collagist, but always a literary collagist in spirit.

Since Greenaway's interest in the contemporary possibilities of the subjects and concerns of traditional painting is mostly explored and developed in cinema, an extended account of his delight in the use of the physical presence of bodies and objects assembled in relation to a text, or 'programme', would belong to another essay. (Which would begin, perhaps, with *A Walk through Prospero's Library*, the short film which names all the figures swelling the procession at the very beginning of *Prospero's Books*.) But the double motion of allegory expressed visually can be suggested.

The body offers wholeness (and accessibility) to the text; abstraction can be earthed in the physical.

This remains a curious and ambiguous area. Should the depicted body itself be abstracted, conceived of as ideal? Or should there be, as in Rubens, an unapologetic use of the flesh that clothes the abstraction (or personifies the personification) as an excess,

supremely and absurdly and delightedly specific – not 'breasts' but *these breasts*? Conceptual and grammatical relations are remade (and, in Rubens, expanded conceptually, *rethought*) as anecdotes, as exuberance. In *Minerva protects Pax from Mars* (*'Peace and War'*) naked Pax breast-feeds naked Plutus, infant god of wealth: a clear economic moral expressed in terms of nurture, but depicted by Rubens through specific, excessive, details. The very act of breast-feeding (and Plutus is not actually at the breast, but drinking from it as if from a fountain) is shown as a sign of plenty, of *surplus*: the jet of milk reaches Plutus's mouth, but some milk spills out (as fruit spills out of the cornucopia directly beneath him), and its path can be followed as it trickles down on to his arm. The virtues and consequences of peace are shown, enacted, eroticised.

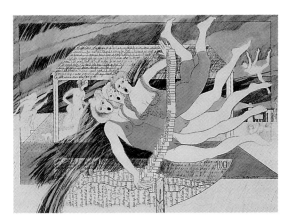

figure 12
The Flying Colpitts 1988
pencil and ink on card, 81 x 112 cm. Collection of the artist.

But if the body offers immediacy and the ease of physicality to the allegorical text, that text characteristically dismembers the body, shredding and distorting it with non-physical meanings it must contort itself to display, stretching it on racks of grammar and association.

If the richness of this first motion of allegory is largely explored in Greenaway's cinema (although a series of allegorical images built up on computer from photographs of naked models is about to be published, see plates 84–6), this second, potentially violent motion of distortion and dismemberment is explored in a series of drawings – again within the Prospero 'project' – which directly link bodies with books. In these drawings – emblems of allegory itself – bodies – male bodies, mostly, with perky erections – are bound up with books, imprisoned in them. The books have blank pages; the bodies are the texts, the subjects – unruly subjects – of the books. As in a related and horrifyingly violent text for *Parkett* (and as in *The Pillow Book*'s later exploration of body as book), there is often an explicit implication or depiction of violence. In *Prospero's Books: A Catalogue*, a female body is shown in a pose, often used by Greenaway, reminiscent of Mantegna's *Dead Christ*, her feet emerging from the opened book as if in the stocks (see figure 11); the opened pages, foreshortened, rhyme disturbingly with both her immediately adjacent sex and pubic triangle and the symmetry of her arms and breasts. Since a similar viewpoint structures the impassive examination of bodies, both male and female, in *Death in the Seine*, there is an unsettling set of equations here between passivity and availability, sex and death, perspective and penetration, reading and looking. Directly beside this image – the sheet contains a grid of twenty-four 'expanded' books, not all including figures – is a reworked Trinity, with the dove of the Holy Spirit in front of a cross, its crossbar piercing the top pages of the book. A pair of legs emerges from the pages just beneath them, wrapped around the vertical of the T, which rests on the spine of the book. (The top of the cross is detached, set back in space.) A drawing made a year earlier, in 1988, shows a more explicit crucifixion, rotated ninety degrees.

AGAINST PERSPECTIVE

In the course of the conversation for this book, Greenaway spoke of 'All those other things that the Renaissance taught us to forget – that Christ is this big [spreads arms] and the apostle is this big [much smaller], which a twelfth century Amiens peasant wouldn't have had a problem with, but subsequent to the Renaissance we all have a problem with, because the Renaissance taught us about illusionism and realism and all those other irrelevant phenomena.'

The camera is stuck with perspective, but cinema no longer is; it can use frames within frames, or use special effects to shrink characters to proportions fitting to their status.

Perspective, in Greenaway's artwork, is generally incorporated into the image as a whole only in relation to flatness; not as an organising principle but as a component within the true organising principles of collage or the grid. This is true of objects and figures drawn by Greenaway himself with reference to perspective (I put it this way because the use of perspective is never assumed, but always draws attention to itself; compare Duchamp's ironic use of diagrammatic images in, and often also about, referring to, perspective), and true also of collaged elements – photographs, reproductions of engravings, and so on. When perspective of a sort is used to organise material it is generally qualified in some way. The game drawings, for example, have borders which reassert the basic flatness of the paper, and include diagrams 'pasted' flat on to the surface, as in *Post and Chairs* (plate 41), which shows the game field both in perspective and diagrammatically in the top right-hand corner. In *The Flying Colpitts* (figure 12), lines which notionally represent the retreat of a roof from the eye are simultaneously used as lines to guide lines of handwriting. The *Death of Webern* drawings from the same year, notably *The Sisters of Strasbourg*, massively qualify the initial impression of recession with a highly unrealistic space poised between collage and historical allegory. More generally, a high view combines with and aspires to the map-like flatness of the aerial view.

(Perspective was of course never a single system. Nor did painters usually adhere slavishly to it. One should also distinguish, as Vasari implicitly does in his close attention to technical developments in *Lives of the Artists*, between perspective as a system of spatial organisation and foreshortening as a way of representing the figure. While the two are clearly related, an enormous amount of Western painting, recognising that perspective offers little help in composing devotional, allegorical or allegorical history paintings, maintains foreshortening while either totally blocking off any recession (often with a highly arbitrary and theatrical use of curtains) or divorcing a crowded foreground from a distant background. Rubens's *Peace and War* is one example of this. Mannerism picked up on Michelangelo's colours, bodies and spaces – spaces which were either crowded or void-like, since, as a sculptor, he lacked Leonardo's or Raphael's interest in perspective as a compositional device. Mannerism was also obsessively and elaborately textual, and practically abolished perspective in favour of pure foreshortening. We could say of the *Prospero's Books* drawings, therefore, that they echo many allegorical, emblematic or text-driven compositions by using foreshortening but not perspective.)

A flat denial of perspective, but not a fetishisation, as in Greenberg, of flatness as a notion, an absolute, an ideal – indeed, a moral ideal. Rather, exploration (impossible in cinema) of the actual properties of surface as and once it receives marks, stains, symbols, colours, fluids, extraneous bits of paper or stuff. The page, the page of script, the sheet of paper: the spaces within which, from which things happen. Little theatres, framed.

THE PLATES

[1] **Nativity Star**
1963

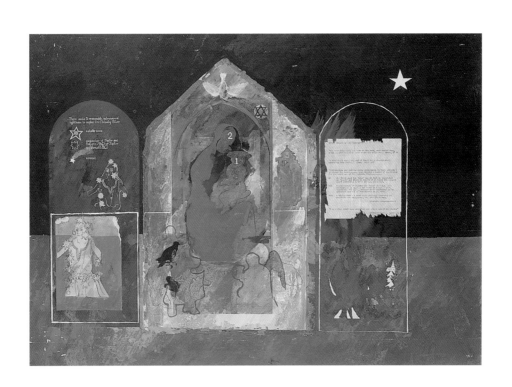

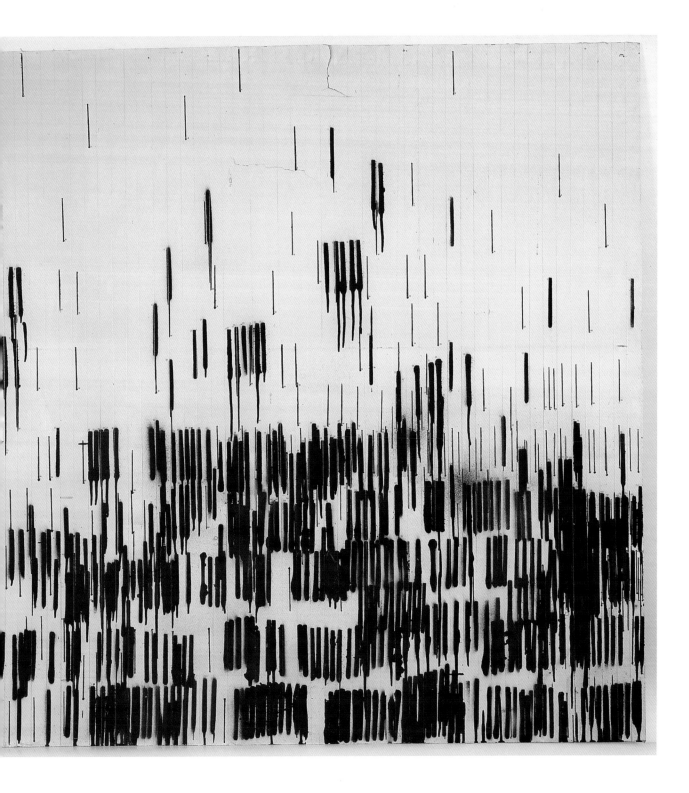

[3] Stellarscape: Verticals
1968

[4] Stellarscape: Semicircle
1968

[5] Star Grid
1968

[6] **Over-painting Three**
1973

[7] Landscape Section:
 Geological Diagram
 1968

[8] Pointillist Relief 1 and 2
 1977

[9] Landscape Section
1972

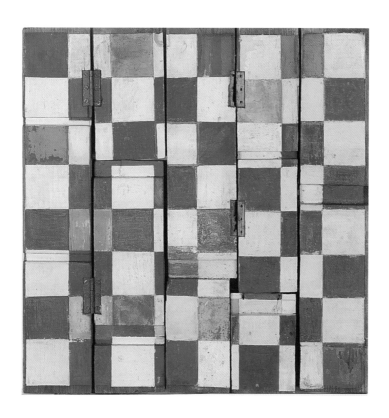

[10] Gaming Board
1968

[11] **If Only Film Could Do the Same**
 1972

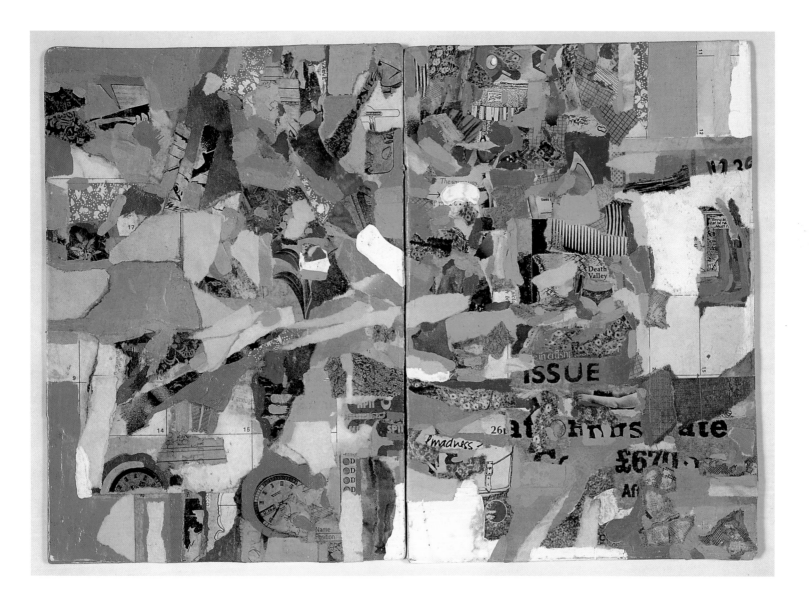

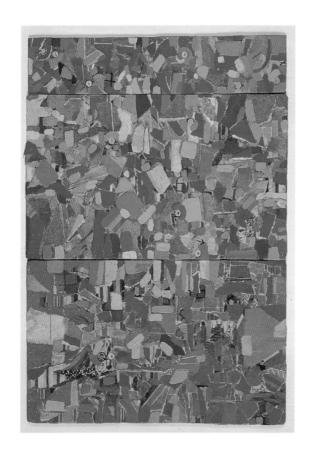

[12] Red Footballers
1972

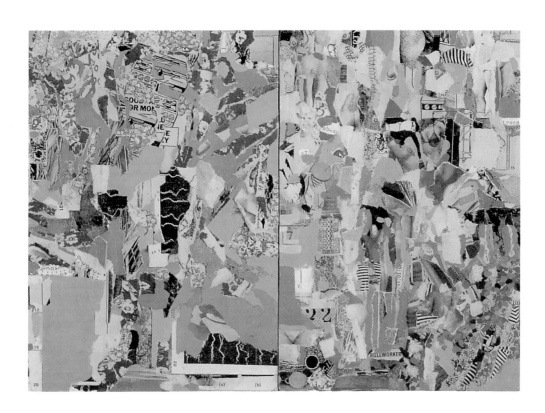

[13] Bullworker
1972

[14] **The Chinese Wallet I**
1972

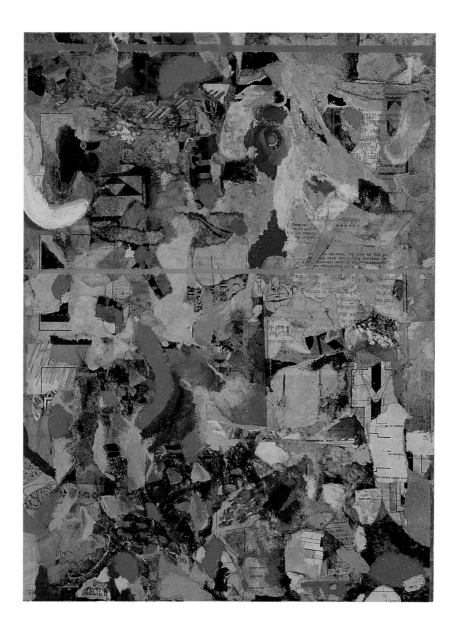

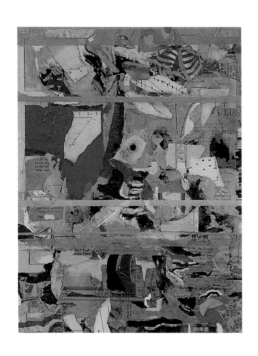 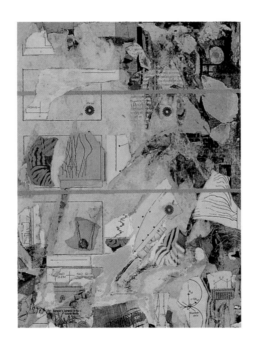 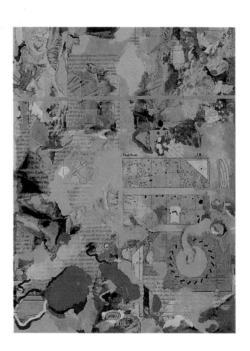

[15] **The Chinese Wallet II**
1972

[16] **The Chinese Wallet III**
1972

[17] **The Chinese Wallet IV**
1972

[18] Vertical Features Remake: The Research 'Glasbury'
1974

Vertical Lists

I Whilst working on "Visual Concepts of Time and Space"
 for Session Three, Marcus Pike spent some time at the
 Centre at Buryglaze. He drew up some plans here for a
 project to which he gave the working title, "Vertical
 Lists". Basically it was a project of organisation; in
 this case, the organisation of a number of images of
 vertical features that Marcus saw and chose to film in
 the square kilometer bounded by the grid lines I70 to
 I8Q and 390 to 400 on Sheet I6I on the First Series of
 the I to 50,000 issue of the Ordnance Survey of Great
 Britain.
 He put the images together in a film some months later
 in Provender and there is a record of the film being
 shown to Tulse Luper and Gang Lion who both later
 participated in the Project for a New Physical World.
 Then the film dissappeared.

2 Pike's notes, drawings and a few of the photographs were
 found at Bridzor some years ago but it is only very
 recently that three damaged negative sections of the film
 were found in a house at Hammersmith among a collection
 of film on the fourth dimension.

3 Before he filmed the images, Marcus Pike drew up several
 schemes for arranging the material. Many of the schemes
 were organised on grids of varying dimension. He wanted an
 an overall regular shape - a square, that could be divided
 up, that would have a single central image and a single
 centre row both down and across. A multiple of any odd
 number would have given these characteristics, but he appears
 appears in the end to have decided on a format of I2I
 images divided into eleven rows of eleven.
 He gave four reasons for having chosen eleven instead of any
 other number. First the number eleven, two verticals, echoes
 the subject matter of the film. Second if the format
 II x II is rearranged it can be made to form a square,
 complete with diagonals,- thus echoing the total shape of the
 of the project and marking by the intersection of the
 diagonals the central image of the project. The third
 reason was that I2I, the multiple of eleven, if written
 I II I the strokes could again be rearranged to make a
 square and fourthly I2I is the same backwards as forwards
 suggesting that the total project was reversible.

[19] **Dear Phone 5**
1973

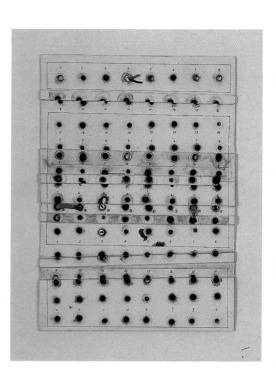

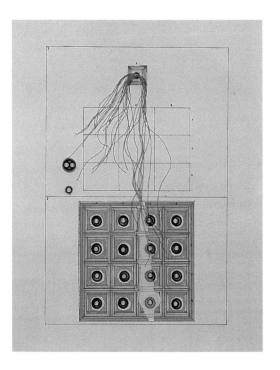

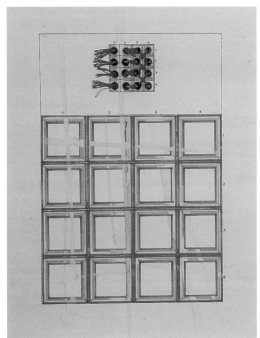

[20] **Dear Phone 8**
1973

[21] **Dear Phone 9**
1973

[22] **Dear Phone (unnumbered)**
1973

[23] **A Walk Through H: Robinson Crusoe on Concrete Island**
1965

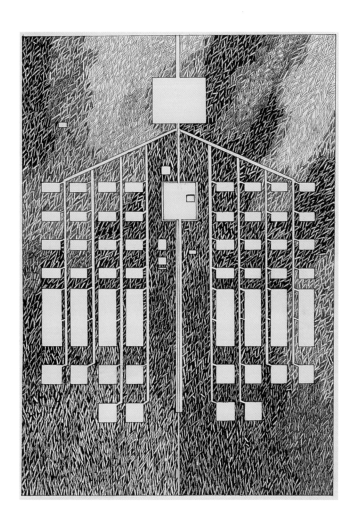

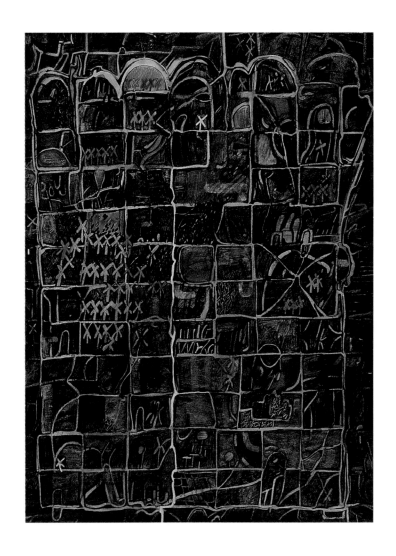

[24] A Walk Through H: The Amsterdam Map
1978

[25] A Walk Through H: Who Killed Cock Robin?
1978

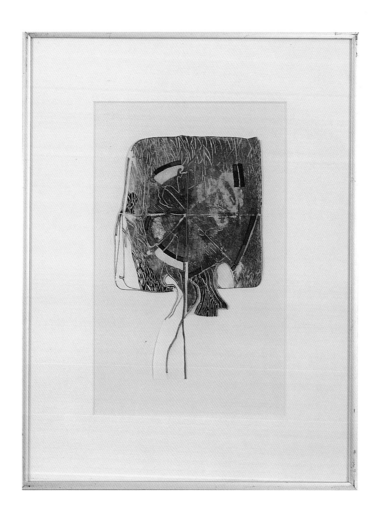

[26] A Walk Through H: Thin Cloud over the Airport
1976–78

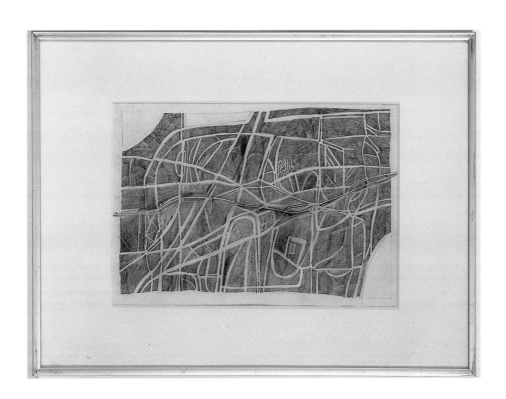

[27] A Walk Through H: Cross-route
1976–78

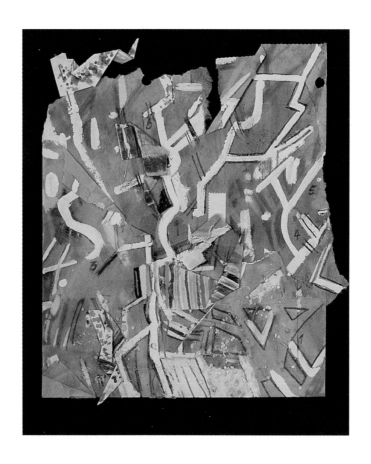

[28] A Walk Through H: Sweet Bag
1976–78

[29] A Walk Through H: Two Small Cities
1976–78

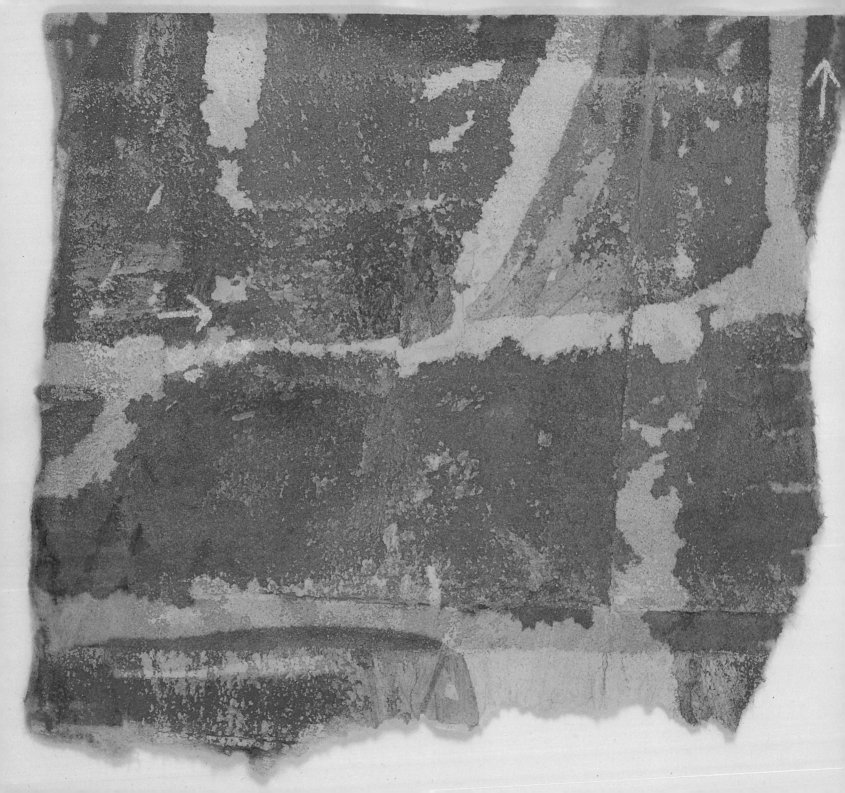

[30] **A Walk Through H: Sandpaper**
1976–78

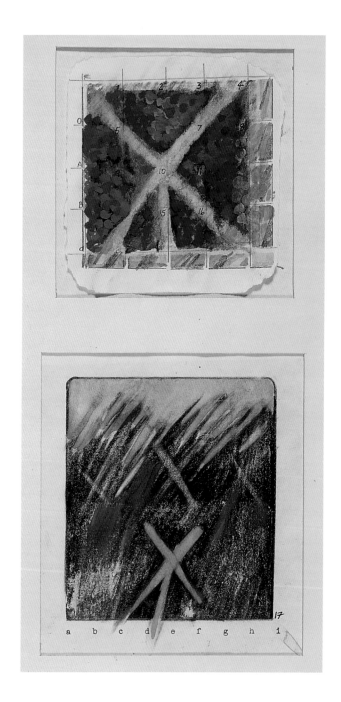

[31] 100 Windmills: Numbers 16–17
1978

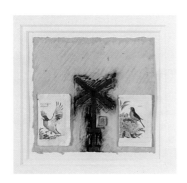

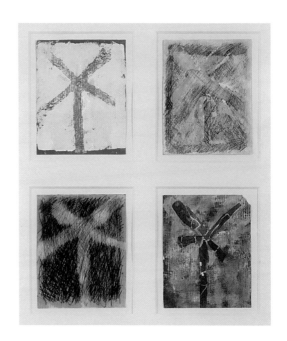

[32] **100 Windmills: Number 7**
1978

[33] **100 Windmills: Numbers 96–9**
1978

[34] **The Falls: Fallaburr**
1978–80

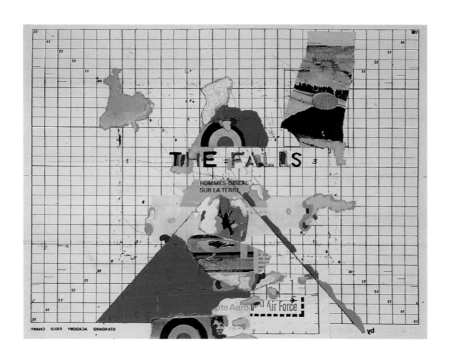

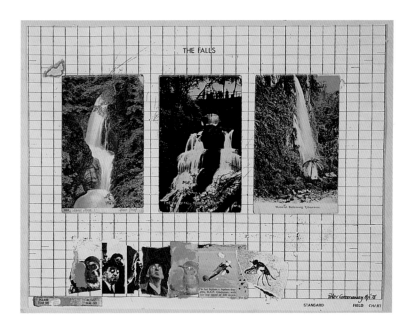

[35] The Falls: Fallabus
1978

[36] The Falls: Fallaby
1978–80

[37] The Falls: Fallacet
1978–80

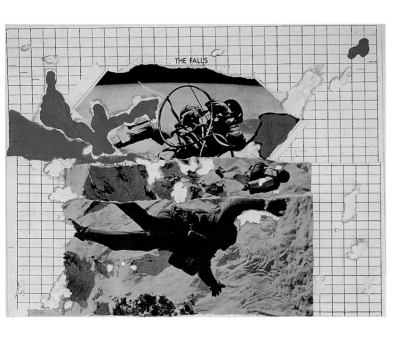

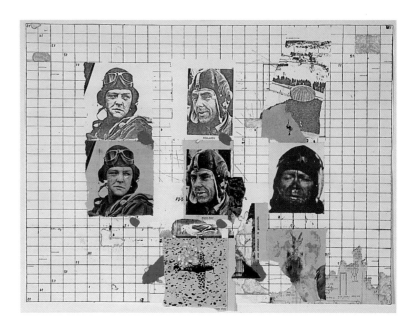

FOLLOWING SPREAD

[38] **The Falls: Fallack**
 1978–80

[39] **The Falls: Fallbatts**
 1978–80

double-spread
hold for
4 sec

double
-spread
for 4 seconds
+

Rea___
4" field.
pan down
for
6 seconds

detail:

'Figured'
chro___

fie___ge
3"

hold for
4 secs.

double-
spread
for
4 sec

double-spread
for ___nds
deto___
3"
cent___
full-s___
after
'areas'
on right-hand
side
hold for
4 seconds

In such a position he stared fixedly
to the southeast. If he had turned h__
gaze forty five degrees, and stared
out due east, he might have faced the
horizon that hid the Lleyn Peninsula
of North Wales, which is what he want__
to stare at.

As it was he misplaced his time,
his energy and his anxiety by
staring at the horizon that hid
the coast of Pembrokeshire which
was much too far to the south.

21239

402

BENCHEKROUN

CASABLANCA

CHICKEN
DRUMSTICKS

Ingredients: Chicken, emulsifying salts, sa

Net weight oz	Price r lb	Price of pack

STANDARD ACADEMY FIELD CHART.

Minimum net weight when froze
3 lb **6** oz **1.53** kg
INGREDIENTS: CHICKEN (WITH GIBLETS),
POLYPHOSPHATES, SALT.

[40] **The Post**
1988

[41] **Post and Chairs**
1988

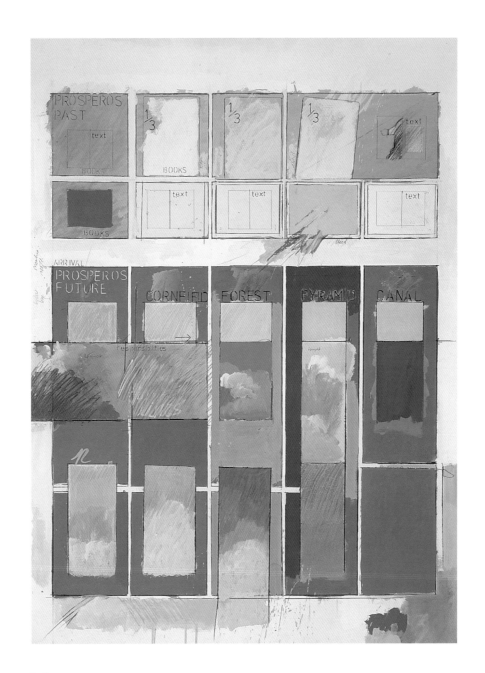

[42] **McCay's Grid**
1989

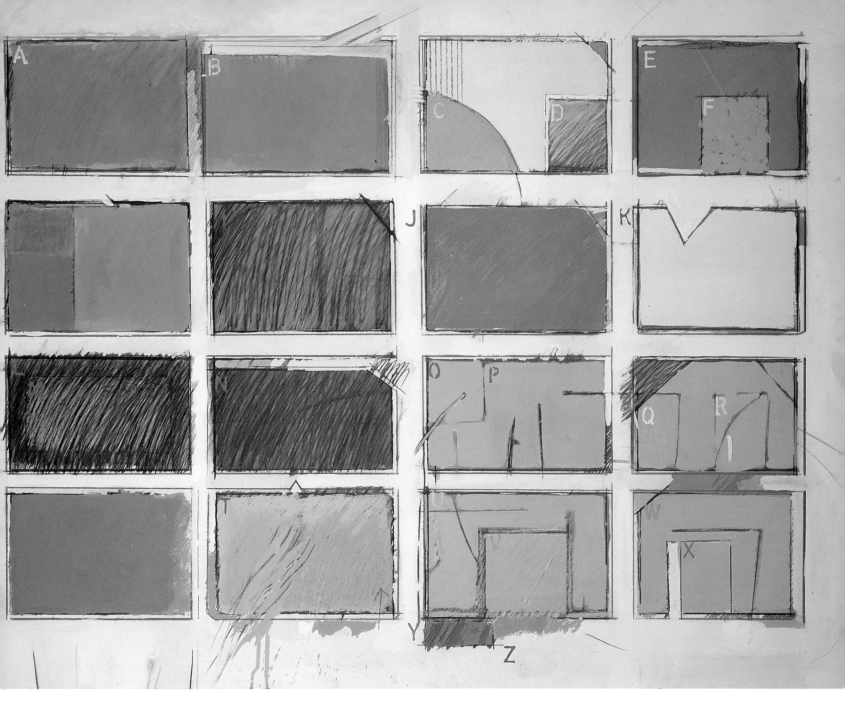

[43] Frame Catalogue
1989

[44] Pages from 'A Framed Life' 1
1989

[45] Pages from 'A Framed Life' 2
1989

[46] Proportional Representation
1989

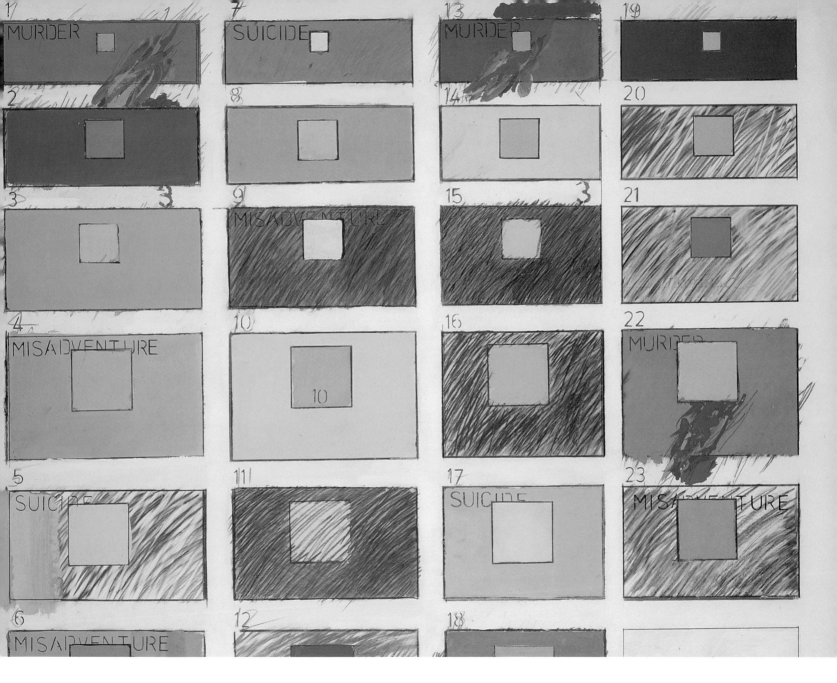

[47] Twenty-three Corpses

1989

[48] **Deus ex Machina**
1990

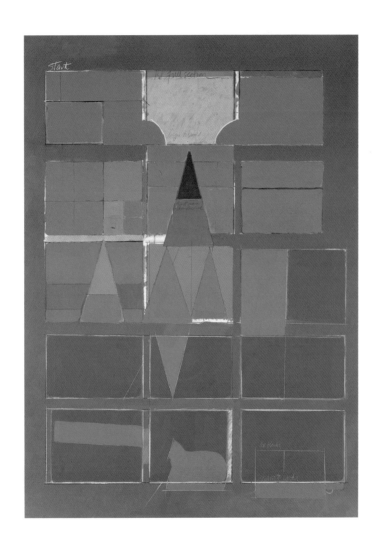

[49] Blackbird Singing in the Dead of Night
1990

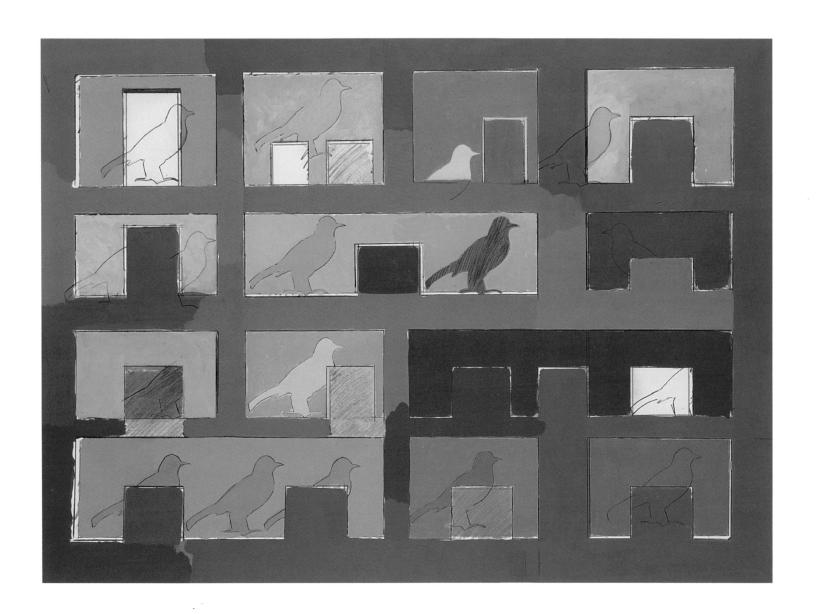

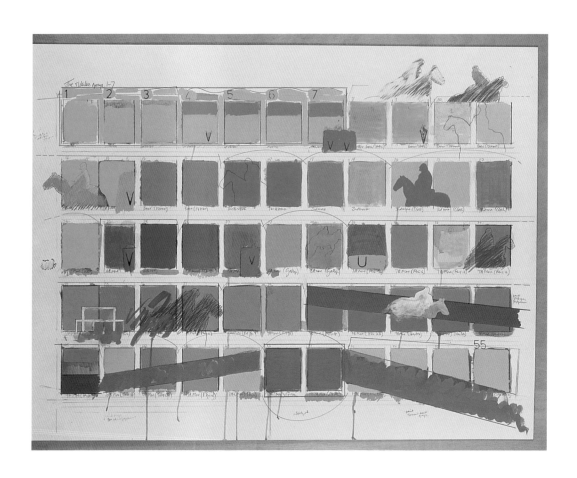

[50] **55 Men on Horseback: Five by Eleven**
1990

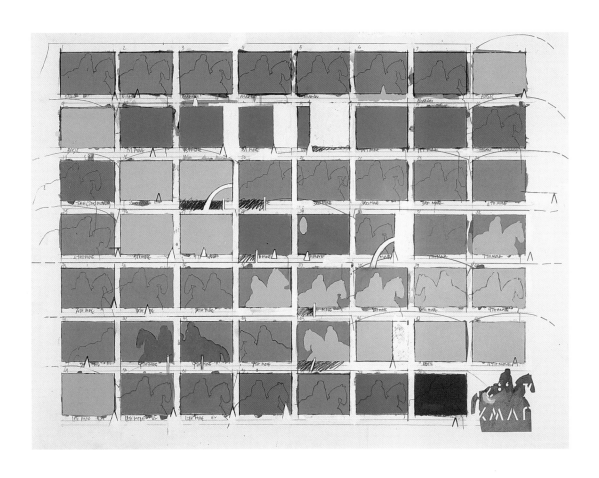

[51] **55 Men on Horseback: Seven by Eight**
1990

[52] **Weighing Horses**
1990

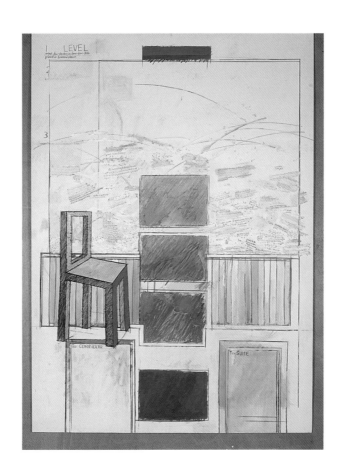

[53] Bathroom Literature
1990

[54] Prospero's Allegories: Night
 1991

[55] Prospero's Allegories: Night I
 1991

[56] Prospero's Allegories: Silenus
 1991

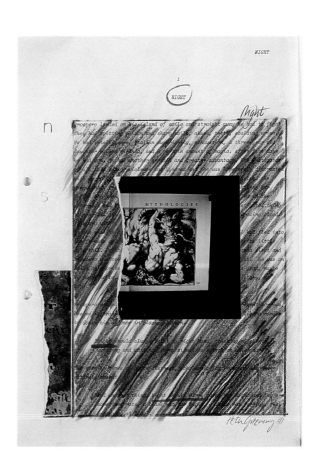

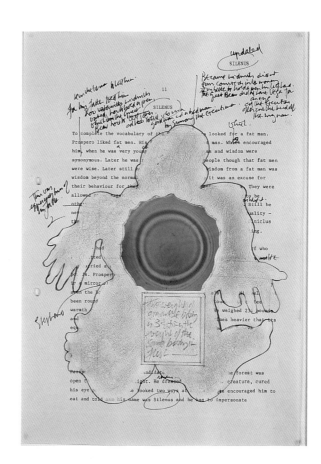

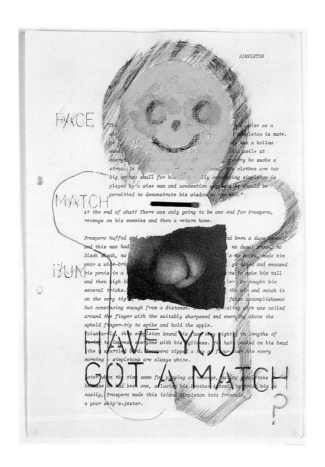

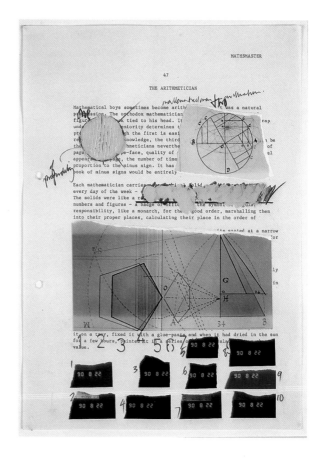

[57] Prospero's Allegories: Simpleton
1991

[58] Prospero's Allegories: The Arithmetician
1991

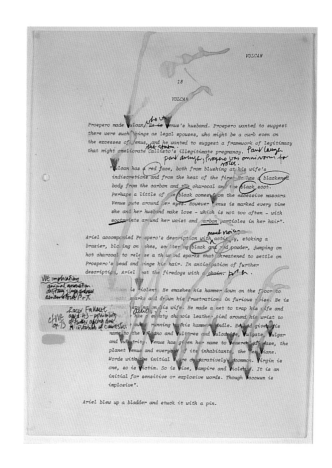

THE AUTHOR OF THE PLAY

A WIDOW PRESENTLY
COURTED BY AN ELDERLY JEWELLER
EXCITED BY HER GAIETY

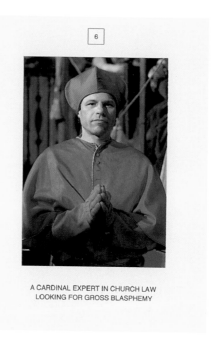

A CARDINAL EXPERT IN CHURCH LAW
LOOKING FOR GROSS BLASPHEMY

[60] The Audience of Mâcon 3
 1992

[61] The Audience of Mâcon 4
 1992

[62] The Audience of Mâcon 6
 1992

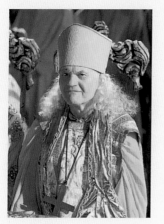

ARCHBISHOP WITH POOR
HEARING WHO RELIED ON HIS
EYESIGHT TO COMPREHEND THE PLAY

THIS WOMAN'S MOTHER
ENCOURAGED HER TO STOOP TO MAKE
SMALL MEN FEEL MORE COMFORTABLE

A WOMAN WHO DONATED MONEY
TO THE THEATRE IN THE BELIEF THAT
IT MORALLY EDUCATES THE ILLITERATE

[63] The Audience of Mâcon 7
1992

[64] The Audience of Mâcon 36
1992

[65] The Audience of Mâcon 100
1992

[66] **The Audience: Text Faces**
1993

[67] The Audience: The Scholars
1993

[68] The Audience: The Cast I First Thought Of
1993

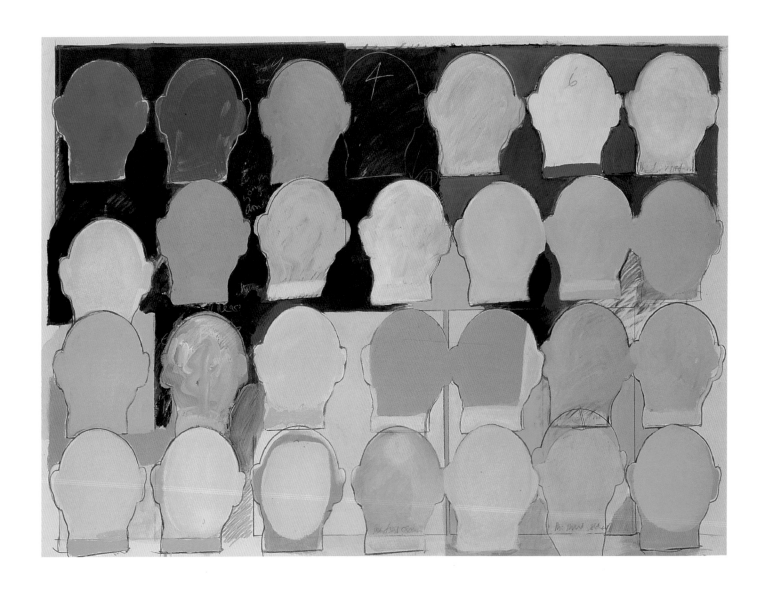

[69] The Audience: Looking for a Small Cast (Black 4)
1993

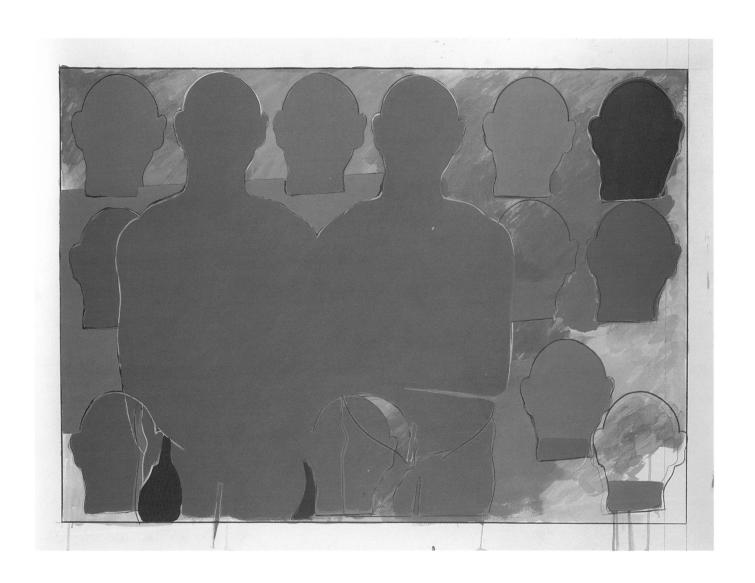

[70] The Audience: Red Twins
1993

[71] **Head Text Series A**
1994

[72] B [73] D [74] E [75] F
[76] N [77] Q [78] R [79] W

HEAD-TEXT '94

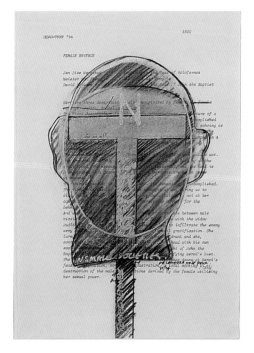

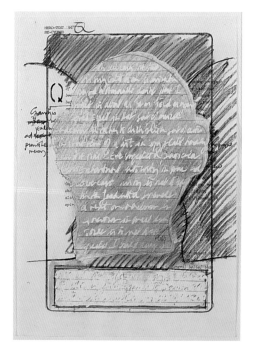

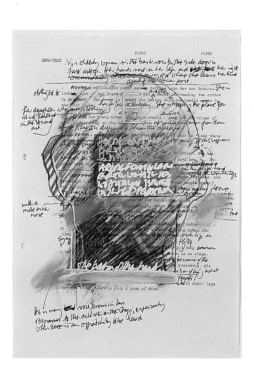

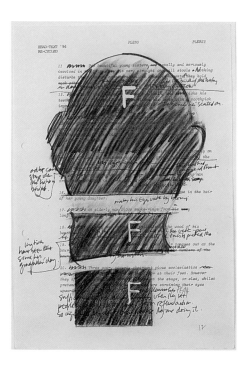

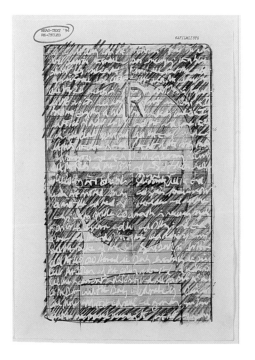

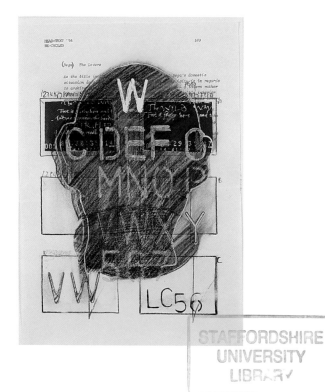

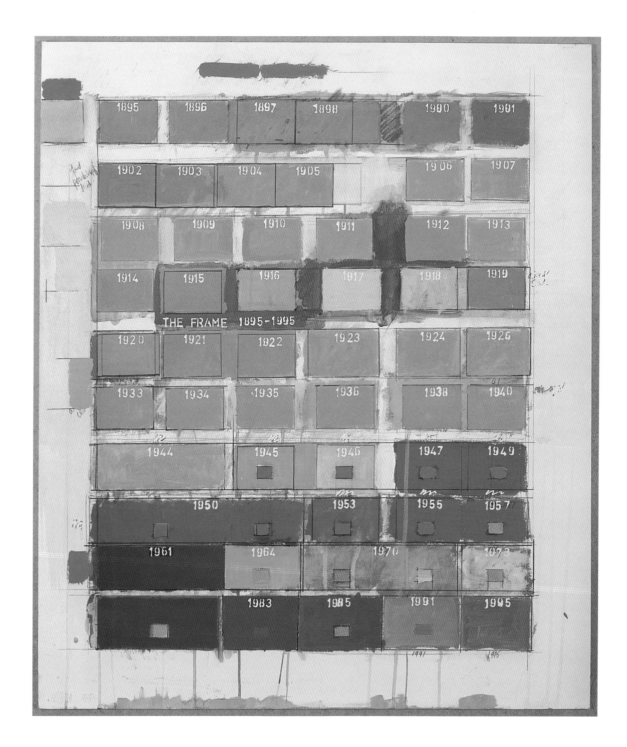

[80] A Short Frame Résumé
1994

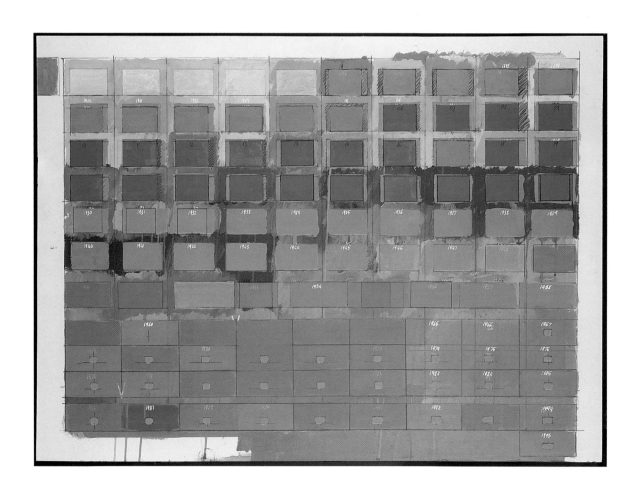

[81] Byzantium
1994

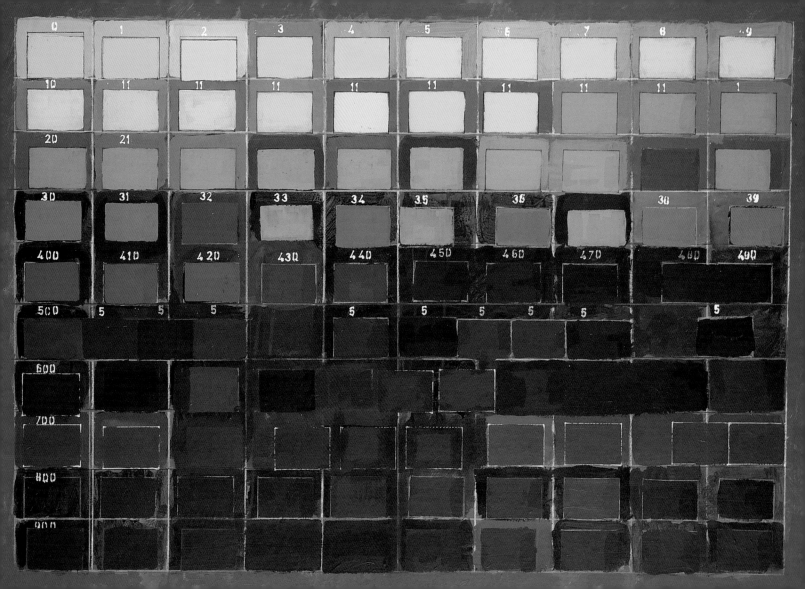

[84] **100 Allegories to Represent the World:
Number 33 – Future**
1996

[85] **100 Allegories to Represent the World: Number 81 – Icarus**
1996

[86] 100 Allegories to Represent the World: Number 93 – Marat
1996

Cinema is text-driven. Despite those who would argue that cinema is a visual medium, the origin of practically every one of its products — like 90 per...

Nous prenons ... **ent d'une main une corne** ... **l'autre des pavots: c'eſt un de ſes f** ...

CAPUT VIII.

*I. Ceres. II. Ceres coronata. III. Stu*ns
Cereris ſtatua. IV. Ceres quæ po
præbet. V. Ceres & Proſerpina. PM

I. FRequentia Cereris ſigna ſunt, ea v
primebatur modis: inde educta multi
rum & hortorum ornamenta. Quæ prim
bula ſequenti offertur, cultum & veſti
trona exhibet. Sub velo aliud viſitur cap
...geribus non rece... orna...

CHAPI...

I. Cerés. II. Cerés couronnée. III. Etrange i
...donne à boire. V. C

I. LEs mon...
rentes n...
' de la planche f...
laiſſe voir un orr...
gulier: elle tien...
de l'autre main...
d'épis, tient er...
ſailles, copiée...
core ³ pour C...
une gerbe &...
Baccante, ou...
nitez qui alloient ſouvent enſemble. L...
figure eſt peu reconnoiſſable, eſt un tigre...

women gr
wear a ve(and mos... of the history of
ground host... for
court ruling Even r this ery
month. The n... ven Ital-
ians and two ...ca.ans, said ...ver... it be
they regarded t... chador as
Iſlamic dress, not an airline
...iform. — Reuter.

Sad nose
A MAN described by polic...
as a "confused vagabond"
used a heavy stone to shatter
or damage 86 busts yesterday
in the Roman park, Villa
Borghese. He was detained
while carrying a bag full of
noses chipped off the stat-
ues. — AP.

Envoy Igor
IGOR ANDROPOV, the son
of the late Soviet leader
Yuri Andropov, has been
named as ambassador to
Greece. The appointment is
yet to be confirmed by Ath-
ens, "but such applications...
...accepted," a

Prime Minis-
al Hasan Ali,
confirmed to
asked to form a
by President
extensive cabi-
is expected to

...ed and
...an ele-
...e with
...piping
...o their
...s were
...when a
...an ele-
...ff the

PEN — 194 —

Penates [dii], tutelar
deities [the penates
Pēnātiger, that carries
Pendeo, pēpendi, ēre,
hang
Pendo, pēpendi, pensum,
ēre, weigh [doubtful
Pendūlus, hanging;
Pēnes, with
Pēnētrālis, penetrable
Penetrāle, n. interior
Pēnētrālis, e, penetrating;
inner
Pēnētro, āre, set; pene-
trate [pencil
Pēnicillum, i, n. painters
Pēnicūlus, i, m. sponge
Pēnis, is, m. tail
Pēnite, inwardly
Pēnitus, a, um, internal
—adv. inwardly
Penna, ae, f. feather;
wing
Pennātus, Pennĭger, win-
ged; feathered
Pennĭpes, ēdis, having
wings on the feet
Pennĭpŏtens, tis, winged
Pensĭlis, e, hanging
Pensio, ōnis, f. payment
Pensĭto, āre, weigh
Penso, āre, weigh; esti-
mate

Pensum, i, n. task
Pēnūria, ae, f. want
Pēnus, us and i, c. pro-
visions [Minerva
Peplum, i, n. mantle of
Per, prep. through
Pēra, ae, f. bag
Pērabsurdus, very absurd
Pērăcer, eris, cre, very
sharp
Pērăcerbus, very harsh
or sour [pleting
Pērăctio, ōnis, f. com-
Pērăcūtē, very sharply
Pērăcūtus, very sharp
Pērădŏlescens, tis, very
young
Pēraeque, very equally
Pērăgĭto, āre, disturb
Pērăgo, ēgi, actum, ēre,
lead through
Pērăgrātio, ōnis f, wan-
dering through
Pērăgro, āvi, ātum, āre,
wander
Pērămans, tis, very loving
Pērămanter, very loving-
ly
Pērambŭlo, āre, walk
through
Pērămoenus, very plea-
sant
Pēramplus, very large [ly
Pērangustē, very narrow-

— 195 — PER

Pērangustus, very narrow
Pēranno, āre, live a year
Pērantĭquus, very old
Pērappŏsĭtus, very suit-
able [cult
Pērarduus, a, very diffi-
Pērargūtus, very witty
Pēraro, āre, plough
through
Pērattentē, very atten-
tively [tive
Pērattentus, very atten-
Perbacchor, āri, revel
Perbeātus, very fortunate
Perbelle, very finely
Perbēne, very well
Perbēnĕvŏlus, very kind
Perbēnignē, very kindly
Perbĭbo, bi, ēre, drink
much
Perblandus, very cour-
teous
Perbŏnus, very good
Perbrĕvis, very short
Perbrĕvĭter, very shortly
Perca, ae, f. fish (perch)
Percaedo, ēre, cut down
Percălesco, lui, ēre, be-
come thoroughly warm
Percallesco, lui, ēre, grow
callous
Percārus, very dear
Percautus, very cautious

Percĕlĕbro, āre, speak of
anything frequently
Percĕlĕr, is, e, very quick
Percĕlĕrĭter, very quickly
Percello, ĕlli, culsum,
ēre, overthrow
Percensĕo, ui, ēre, count
Perceptio, ōnis, f. per-
ception [cut up
Percĭdo, di, sum, ēre,
Percĭeo, īvi and ĭi, itum,
ēre, stir
Percĭtus, irritable
Percĭpio, ēpi, eptum, ēre,
take possession of
Percĭvīlis, very courteous
Percōlo, āre, filter
Percŏmis, e, very friendly
Percommŏdē, very con-
veniently [able
Percommŏdus, very suit-
Percontātĭo, ōnis, f. in-
quiring [quirer
Percontātor, ōris, m. in-
Percontor, āri, inquire
Percŏquo, xi, ctum, ēre,
boil thoroughly
Percrēbresco, brui, ēre,
become very frequent
Percrĕpo, ui, ĭtum, āre,
resound

[88] **In the Dark: Audience**
1996

[87] **In the Dark: Sad Nose Text**
1996

[89] **In the Dark: Child Actors**
1996

[90] **In the Dark: Hydrobiology**
1996

ILLUSION

On the wall/screen above
projection-white - are 10
longest-lasting cinema-sc
lighting-effect familiar
water, fire, fog, rain, f

We might expand this - po
same screen, and include
the Scottish moor, the ai
terior, the lift-shaft, lobby, the bedroom, the office

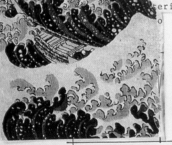

HYDROBIOLOGIE

[91] **Some Very Low Temperatures**
1997

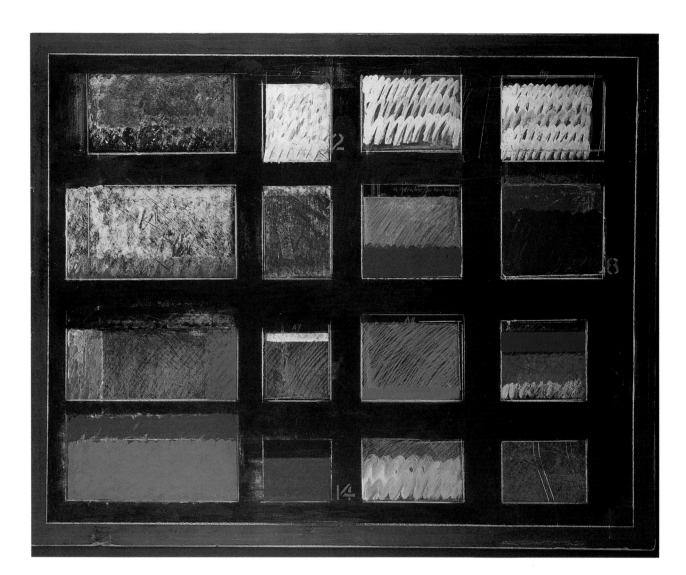

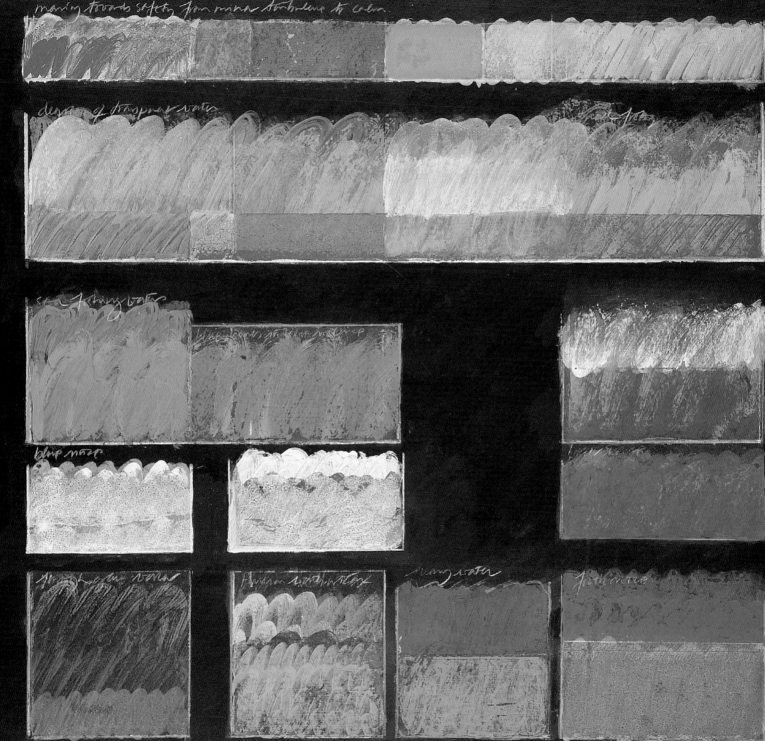

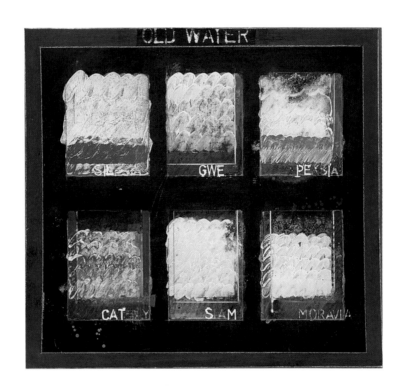

[92] Moving Towards Safety
1997

[93] Old Water
1997

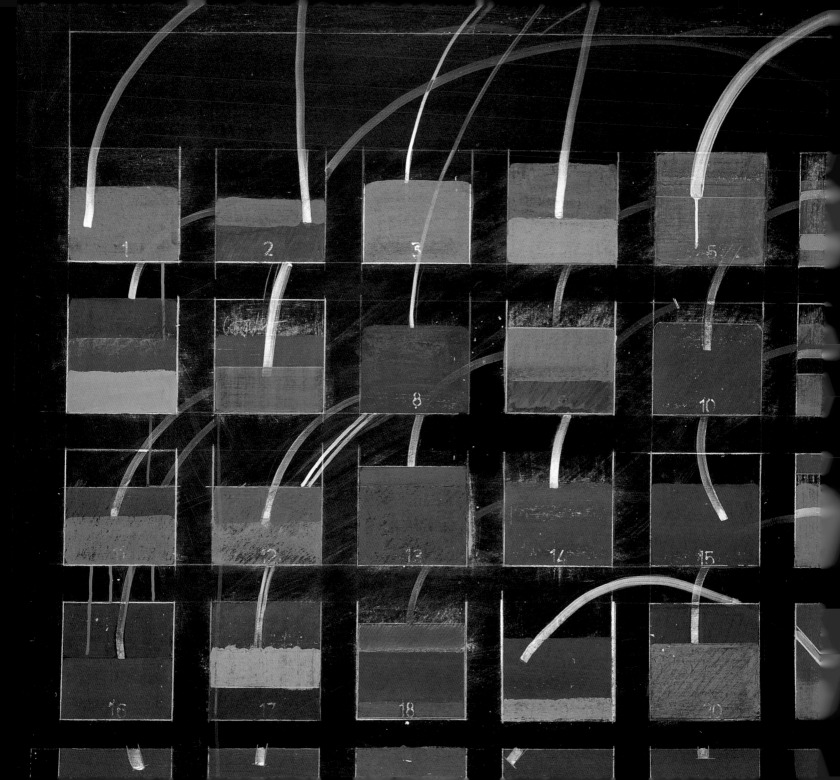

[94] Icarus Falling into Water
1997

[95] **Choosing a Colour for Rosa's Blood**
1997

[96] **Half Woman**
1998

ARTS *of* PAINTING

An interview with Peter Greenaway by Alan Woods

You often say that the ideas are the most important thing in your work. I don't know how much sense it makes to divide up your work by different media, but are there any specifically painting ideas that are important?

Perhaps, in structure, the paintings are self-consciously about visual listings, cataloguing, organisation. The paintings could not be described as figurative, but then neither are they without figuration. They have always been concerned schematically with ways and means of visually organising many different types of material and information – but in often severely stripped down form. The films are not by any means stripped down. They self-evidently are indeed figurative. Baroquely and excessively so. They involve large numbers of people, excess dialogue, multi-layered and crowded narrative, anecdotes of flesh and blood, of sexuality and physicality. The film making for me takes care of a large area of visual figurative material which I am indeed fascinated by and interested in – it is perhaps – if you like – a filling-in of non-figurative painting's content. My paintings would not involve direct depictions of observed visual states, or any real conscious exchange of political thought and social order and psychological drama; much of that material is undertaken and developed in the films. Although there is a great concern for form and numerous schematic formal devices in the films, in the paintings there is an even higher bias towards the formal, a more naked and simpler delight in organisation and classification. The paintings, or works on paper, have much to do with maps, plans, diagrams – schematic organisations of phenomena in one respect or another – in some cases very self-reflexively, so it can just simply

concern itself with colour squares, and through them about the way that the paint hits the paper in different ways. Such a statement does sound too simple, but the broad outlines are probably relevant. I'm never likely, for example, to make an illusionistic Veronese painting, a Marriage at Cana, much as I admire it and paintings like it, but I would want to make it the subject of a film of the Marriage of Christ – a coded tableau of a hundred and fifty characters interacting anecdotally with great aplomb – somehow subversively against the wishes of a church who wanted to keep Christ a bachelor and a virgin. I would be very happy to do that in an ironically cinematic context but only explore it diagrammatically in a series of paintings. And the idea of the paintings might be to make a subversive list and catalogue of possibilities of Christ being a married man. And the identity of his wife. Perhaps the paintings set up the ground for the films and then comment on them. Then again perhaps it is the other way around. I would not want to wholly separate out the painting and the film making as two wholly different activities. And I've got to be aware of the paradoxes – I often convince myself I want to make abstract films, though I don't know quite what an abstract film is, and I could imagine it would become rapidly tedious. I've just spent eight and a half weeks shooting a film called **Eight and a half Women** with eight and a half actors. I have often wished that actors were not necessary. I don't particularly like what actors are traditionally supposed to be for. But their essential figuration and their sense of performance and their sense of representing human experiences in ways that we can understand is absolutely a part of contemporary cinema. I do not think I can successfully exchange actors for diagrams. It is ironic that most film animation is figurative.

You could say that the early films were more abstract, if abstract suggests a lack of models, or figures, or actors. (Though not characters...)

Many of the early films were really an excuse to put my drawings or paintings on to celluloid, the most naked example being *A Walk Through H*, a filmed exhibition of my paintings conceived and organised to explain a narrative – the paintings came first, the film second (plates 23–30, figure 10). This approach has not been completely ignored in some of the other films – though *The Draughtsman's Contract* has the opposite approach – the drawings had to be made for the film and not the other way round. There are different connections. There is a painting I made whilst writing the script for the current film, *Eight and a half Women* (plate 97). A large branch blown down in the garden of my house in Wales resembled the lower half of a female. I made a painting of the branch to suggest a Greek antique – a fragmented female – making her a classic passive sexual object. I wanted to hang the painting on a wall in one of the film sets – it was supposedly going to fall from the wall in an earthquake – there are three earthquakes in the film. A fallen branch making a fallen antique to fall from a wall in an earthquake. When it came to it, I didn't use the painting in the film – I think my excuse was that I didn't want it to get damaged in a pseudo-cinematic earthquake.

You have always emphasised the relevance of the history of painting for cinema.

In conservative moments, I would say that the best place for film schools to be organised would be in conjunction with art schools – look at, study painting and paint for three years before you dare pick up a camera, because the film maker should be the conscious inheritor of an extraordinary and encyclopaedic tradition of making images associated with painting. A successful painter is an expert at the manufacture of an image. When any film maker makes an image, at least ten thousand painters have been there before. We normally prize experts. We should sensibly look over our shoulder to see what they've done, to see what the successes have been, what the history of their achievement is, why the heritage is as it is, to learn from it. The substance of the spoken word and the written text in which we are all such experts after such long and careful training, practice and education are full of references, direct and indirect, conscious and unconscious. There is no such general training in the business of making and receiving visual images. It strikes me that the body of visual reference that has been created over the last five thousand years is essential. I think that there are very few films that are as visually investigative as most successful paintings have been.

The new film finally has a film maker as the central character?

No – there are no film-makers but a son who persuades his father to take on film images enthusiastically. *Eight and a half Women* , by its title, is in small part, a homage to perhaps the most successful film ever made about the conception of a film. There have been many films made about making films – Truffaut's *Day for Night*, for example – but very few films about where those ideas come from, how they enter the imagination of a film maker, how they're used, how they are manipulated, how they fit into cinema practice. Fellini's *8 ¹/2* is important, I suspect, for every cinema maker for this reason. But *Eight and a half Women* has other interests starting from the Fellini original – from the celebrated male fantasy sequence in that film – for the film *Eight and a half Women* is wrapped around eight and a half male sexual stereotypical classic fantasises often reprised in the novel, film, painting and public folklore. Probably most of my films have had veiled references to the business of making cinema. Which is not the same thing as making films about movie making. Now I have finally accepted it. I always thought that making films about film making was too incestuous and too self-indulgent. Perhaps *The Belly of an Architect* could have been called maybe *The Belly of a Film Maker*, *The Draughtsman's Contract* could have been called maybe *The Film Maker's Contract*, but the films have all been slightly removed from a perspective which certainly at that time I

thought would have been talking too directly about my own business. So now I've come out into the open. The new film starts with quoting Fellini and finishes with a nod towards Godard. The narrative activity stretches between Geneva and Kyoto, and there is a gentle remark made by a Godard character, which is quoted in *Eight and a half Women*, that 'the most beautiful women in the world can be found on the road between Geneva and Lausanne'. We take the example of women and male sexual fantasy imagined through that Fellini approach at the beginning of the film, and at the end there is the notion of the female as seen by Godard, which is different, more contemporary, stronger, cynical, more acerbic, and has a different perspective. There's something a little impossible about Fellini's notion of the female. It curiously stays a fantasy, a sort of game, it's held at a distance. It's both romantic and literary. Whereas in *Eight and a half Women* I suppose I like to think there is a far more Godardian edge to things. People do fantasise but the fantasies are faulty, and there are problems and considerable male anxiety. The women tend to take the male dreams to a point of exhaustion.

Could you say something about your routines regarding the paintings and works on paper? They've always gone on alongside everything else.

There's a small preface in *Papers*: 'The paintings and the collages represent a small part of the speculative investigation that, for me, is carried on across a wide front in collaboration with the manufacture of film. My initial enthusiasm for becoming a film maker arose from a dual interest in the manipulation of images and the manipulation of words.' Often the drawings, the works on paper or the more finished paintings relate in many ways to what's going on in the films. The obvious example is *The Draughtsman's Contract*, which is a film about thirteen drawings, and the film can't exist without the drawings. They are drawings made for a very, very specific purpose, to contain a series of clues to make the narrative of *The Draughtsman's Contract* work. I do not think they should be seen outside of the film. The film narrative suggests they were burnt – we

should perhaps preserve that idea. We've talked about *A Walk Through H*. The original drawings for that film are very small and it was a delight to rostrum them with close-up lenses to appreciate the weave and staining of the paper and the details of the paint on the paper's surface. The enlarging could only be done photographically and if those photo-images move – then so much more exciting – the eye can travel across those small surfaces like a plane across an artificial and fictional landscape. It is difficult to think of a similar experience in any other medium. Paint and camera adding something together unobtainable anywhere else. I have used the same special relationship of camera and painting in making slides for opera projections – very small images enlarged some thirty metres across – making very special characteristics of scale – it is like allowing a singer to use amplified sound – he or she can whisper and sigh and make very small sounds and still be heard like a Wagnerian soloist.

There are a number of paintings which are schemes for movies – one example – two paintings called *55 Men on Horseback* – a title itself derived from a set of fifty-five Viennese late eighteenth century equestrian gouaches at Wilton House (plates 50–1). I wrote a novel of the same name involving George Stubbs painting and overpainting an adulterous horsewoman alongside many passions for horses and horseflesh and horsewomen. I wrote the novel as though I was writing a film script and hope one day to make the film. Though it is long – very long – there are fifty-five horse stories within the novel – each horse story corresponding intimately with one of the original Wilton House paintings. Perhaps many of the horse interests have now gone into the Amsterdam opera *Rosa*. Wanting to see if it was possible to create a chronology of a certain sort for the future film – I made these two paintings which marked and charted out all the different emphases of the plotting. There are many indications of crescendos of activity, and there are notions of apotheosis and bathos diagrammatically charted. There are also various pointers, marks and colour codings which relate to film editing pace, pauses and montages. So these are working drawings, if you like, for the manufacture of a film. But having looked at them and played with them, all other sorts of anecdotal information

begin to appear to be significant. Inevitably the paint splashes and dribbles themselves become events which are just as important as what is intentionally, intellectually, devised.

There are many other kinds of relationships. These works can be made before, during and after the films are made. Many of the images are afterthoughts. Maybe, hearing somebody make a comment about a film of mine I've thought about it again, and somehow reworked it, or reconsidered it – it is practically impossible to remake the film – but I can easily reconsider the film, or some part of the film, as a painting.

In the reworked Kitaj sense, some films have books, some books have films. There's a constant referencing backwards and forwards. In the end there is probably no single painting or drawn image that doesn't have some of my thoughts about film making. And if I didn't say that it would be wholly dishonest, since I regard myself as an image maker, and whether those images are on celluloid or on paper in the end can seem irrelevant to me. It's all part of a general fascination about the making of images.

Of course, that general fascination includes a fascination with the different possibilities of different media. You have spoken about how as a filmmaker you make thousands and thousands of images – every frame of film shot is a distinct image, and there are thousands of production stills. And that is an advantage, but also one of the great advantages of paint – for the viewer as much as the artist – is its slowness. It stays there, it doesn't go away, there's been work done which is mirrored by the work done in looking at it.

Those sets of relationships are always interesting. Paintings are unique – even painted copies of paintings are unique. Looking at Caravaggio and at La Tour, their own copies of their own paintings tell you that. But copies of films are not. Film copying is infinitely reproducible. A painting has a uniqueness that never exists in film making. There's also a way in which time is inimicable to the film-making process because time destroys celluloid to its great disadvantage – time may curiously and in a strange way be sometimes useful and advantageous to paintings. The appearance of crackle, the notion of white paint aging, the settling in of colour are items of interest in themselves. If you go and look at a Mondrian close to it can be surprising. There is a presumption – experienced no doubt by antiseptic reproduction – that the works are pristine and impersonal. But here is a hair from the brush and there is a thumbprint and overall there is extensive discolouring and much collapse of the original paint surface. There is a short ironic anti-Mondrian sequence in *Eight and a half Women*, where it is more important to see Mondrian as a great tango dancer than as a great painter. The fake Mondrians were carefully observed – there is much surface crackle – the personality of the originals has been removed. There's also another curious situation where paintings create a provenance which is impossible to recreate in any sense in film making. If you hang a painting in a certain space, gallery, room, it does something to the room. You can, I believe, play a film in any cinema in the world and it makes no impact at all on the place it's played in. The sheer excitements of just looking at a painting are very difficult to reproduce in any cinematic context. I have often tried to reproduce the steady contemplation of a cinematic image as though it was a painting. I am not so sure that audiences want to apply the same scrutiny to a cinematic image as they would be prepared to apply to a painting. And the ready availability of painting and the non-ready availability of film is frustrating. A painting in the National Gallery can be reliably visited daily. You know it's there. To gain access to a known image by Buñuel or Fellini or Pasolini is very difficult. To possess a video of the same is not the same.

Maybe it's vainglorious and egotistical, but I like looking at my own paintings, particularly those which are maybe ten years old and have passed through some sort of sea-change. The delights and remembrances of the experience of making the painting, the sheer physicality of the phenomena, can be very exciting to contemplate. I rarely have the same excitements at the thought of looking at images in my own films. That painterly excitement would always make me wish to continue to manufacture painting.

That difficulty of access means that our sense of film is massively dependent on our memory of a work – even with video it is difficult to simply look up the image we want to return to, which we remember, or think we remember. And what we easily forget, as viewers or critics, I suppose, is how difficult it was for Buñuel himself to access Buñuel images.

We are talking in Luxembourg. And we have been using a Luxembourg cinema as a location for **Eight and a half Women**. Part of the public relations access to the cinema as a location was to show a film of mine here. They chose to show **The Cook, the Thief, his Wife and her Lover**. I hadn't seen the film myself for several years on a big screen. I was surprised.

I had forgotten how beautiful some of those camera movements were, and how amazing the Sacha Vierny photography is, most especially the richness of the colour, and the drama of Michael Nyman's music. I thought everyone's contribution was great – save strangely my own – which seemed coarse and hesitant. And too self-conscious. I was proud of all the contributions of the collaborators and somehow embarrassed by what I recognised as my contribution.

But then I would always far rather visit a painting gallery than a cinema. That's a curious thing perhaps for a film maker to say. I am a poor cinema spectator, but I seldom do not enjoy filming. Yesterday we finished principal photography on the film. I enjoy coming to the set in the early morning, and inventing with thirty or forty crew members who help to flesh out, expand and reproduce these invented ideas. It's an experience I often wish would continue ceaselessly. But now, after those excitements, I have to sit down with the editor and put the whole puzzle together. I'm not looking forward to it. I expect it will be another long and over-length film to start with. Most of the excitement has been already used up in some ways. Maybe even earlier on, when the idea was conceived and written down, it was even more exciting. So from the moment of the finished script, when one hopes all the ideas are consolidated, it's a downhill slope and slide. In much cinema practice it's a common studio insistence, making another intermediary stage, which so far – touch wood – I am not obliged to become involved in, and that is to make storyboards. Because I feel that would really dissipate the energy. Because if you plan every image carefully and thoroughly on a piece of paper beforehand – what is there left to do – that way you become an an illustrator of drawings – not a maker of cinema images.

Could we talk about drawing?

What would you like me to say? It can be done simply, and easily, and quickly – and almost invisibly, too, which is quite a satisfactory way of thinking about it. Most of the drawing would never be objective. I would be unlikely to sit down in front of a bunch of flowers – that doesn't particularly interest me too much, though I have a strong visual memory and might be able to reproduce a situation like that later. Again, the greatest excitement is the sheer excitement of the mark on the page, being faced with an empty page and having a sharp pencil in your hand. There's always, always an immense excitement and you look forward to it. Whether the drawings are to exist in their own right, or whether they're an investigative prelude to something else, I wouldn't even bother to worry about. That seems to me to be irrelevant.

This was a long time ago, but you have described a day spent trying to draw the outside of a house in Hay-on-Wye, but full of interruptions, as the start of the idea for **The Draughtsman's Contract**. *It sounds like you wouldn't make that kind of drawing now?*

No, it is unlikely. I wouldn't do that. My practice has changed in that respect. I would not necessarily have that amount of patience to do it. It would be impossible for me to make **The Draughtsman's Contract** now. My interests would be very different, so much so that at last, after long resistance, I am negotiating for an American company to remake it.

There is a lot of numbering going on alongside the use of text.

I have no belief in the magic of numbers, nor do I hold any mystical or mythical belief associated with them. One can gain some degree of comfort from the notion that 2+2 is always 4, even if in some effete branch of astro-physics that probably cannot be said to be absolutely true any more. The knowledge that the arithmetical system has a complete logic that everybody understands, which most systems of ordering do not, is comforting. Linnaean systems of nomenclature, identification of colour, scale, distance, type, size, are all subjective. Most systems are based finally upon forms of subjectivity. I do also enjoy that sort of list making – the Borgesian Chinese Encyclopaedia categories are salutary. But my main reason is to use numerical codes, equations and countings as an alternative to narrative dominance. I make catalogue movies. I am very dubious about the use of narrative in cinema, but if you don't have narrative, if you throw away that prop, you still have to organise the material in a comprehensible way. How can you develop a neutral structure? The use of numbers, numbering and numerical codes has been one of the characteristics of twentieth century art – Jasper Johns's use of numbers and alphabets and maps, Sol LeWitt's notion of grid systems. I've often tried to use these as a substitute, or to run parallel with the notion of a narrative. And the narratives I've used are also very stereotypical, stripped back, archetypal, they're generally reworked fables and mythologies, avoiding excess anecdote, especially psychological anecdote. There are two prime reasons. One, let's have a visual cinema, not a textual cinema, or a literary cinema, or a cinema illustrating text. And two, writing narratives comes easily to me, so I feel excess narrative writing is a rather dubious area which is associated with cleverness and superficiality. We are preparing now a new film, called **The Tulse Luper Suitcase** – it's based upon the history of uranium, and the atomic number of uranium – 92 – is going to be significant – there's ninety-two of this and ninety-two of that. One of the characters is rewriting the thousand and one tales of Sheherazade. I don't find it difficult to do – I haven't written one thousand and one yet, but we're up into the seven hundreds. It's not difficult for me to concern myself with

narrative, so therefore I feel very suspect about it. So it's to do with that sense of insecurity, I suppose; I want to have more non-anecdotal material, more classic, down-the-line material which is related to verities as opposed to superficialities. How I go about that – because my films are full of anecdotes anyway – it's full of all sorts of paradoxes and contradictions again. But those are the structures that I work from, and most of my ideas are essentially to do with classification first, because most of the movies are catalogue movies. Sometimes the catalogue is very disguised, and sometimes it's obvious. **Death in the Seine**, for example is a very obvious catalogue of people who met their death in the Seine around the time of the French Revolution. It is not difficult to see **Eight and a half Women** as an ironic catalogue relative to the Fellini original.

*Ask people about a film, and they will normally try and tell you the story. I never understood why **Sight and Sound** précis the narrative alongside their reviews.*

I have come to the conclusion that curiously I don't think film is a very good narrative medium. If I was to ask you to tell me the full story of **Casablanca**, or **La Dolce Vita**, I bet you couldn't do it. Because I don't think people do remember close narrative or close story-telling in the cinema. They remember ambience, they remember event, they remember incidents, performance, atmosphere, a line of dialogue, a sense of *genius loci*, but I really doubt whether they truly remember narrative. I would argue that if you want to write narratives, be an author, be a novelist, don't be a film maker. Because I believe film making is so much more exciting in areas which aren't primarily to do with narrative.

Relevant also to your question is my concern about the uses of text and image and their conjunctions in the cinema. On primitive levels simply, what comes first? Does text engender image, does image engender text, what are the relationships? Was the visual world a different place before universal literacy? Many questions. Have we seen any cinema yet – or have we just had a hundred years of illustrated text?

Can we go right back to the beginning? Kitaj's influence you have openly acknowledged, Peter Blake was at Walthamstow when you were a student there, you went on to work with Tom Phillips on **A TV Dante** *– looking at the very early work you can see –*

The influences are strong, you can see that. But there are others.

And there was also Land art, which wasn't painting. I was wondering what it meant to you back then to say, 'I want to be a painter, I want to be an artist'?

Initially, of course, I didn't say it out very loud, because it was a strange thing to say. My family had no yardstick to consider the matter. 'I want to be a chartered accountant' could be understandable in my family, though even they would have considered it dull. 'I want to be an architect' – that was possible, if a little grand, but to be a painter sounded like an unlikely dream, a wish fulfilment that would never happen. I'm sure that all children are potentially visually capable of great expressive possibilities, but our education system does not regard visual communication as so very important. It is very subtly discouraged, so that most people's visual potential within themselves is jettisoned. There was someone who encouraged me when I was very young to consider painting was important, so from the age of eleven or twelve there was always the feeling that painting was exciting, enjoyable and worth while, and could be given a value – a value which my parents certainly would not have given it. I suspect that would be most people's experience. It would be an incomprehensible world. On one level few people would understand what was going on in twentieth century art anyway. My parents' and grandparents' generation would support and laud middle-period highly realistic Victorian painting because they could understand that there was a text being interpreted and illustrated. So the relationship I had with this particular teacher who encouraged me was something I didn't talk about. I wasn't encouraged to talk about it, but I remember it was something that gave me a satisfied expectation of myself, so I quietly continued, denigrating my interest if necessary when it was questioned or derided, to protect it. By the time I was about fourteen or fifteen I'd become very fascinated by landscape painting.

I come from a background of horticulturalists. My grandfather was a gardener and nurseryman, and my father's relatives were small tenant land-holders in Norfolk and Suffolk. I had a knowledge of horticultural matters and natural history – largely through my grandparents. My father's obsession was bird watching. I often think it was his excuse to walk wild landscape – preferably marshes and beaches. So almost by osmosis a mass of natural history and landscape information came into my background and memory without me particularly realising it. As an early adolescent I was always surprised that most people didn't know the difference between a skylark and a chaffinch. Most children seemed to know the difference between a Daimler-Benz and a Porsche. I doubt that I could tell with certainty. Then or now. That background made the sorts of marks I made on paper relative to landscape. I bicycled around Essex drawing. I spent the long summer holidays in South Wales with my Welsh relatives drawing coal pits and mountains. I wanted to see what others had done and haunted the public libraries in Walthamstow and Woodford, in east London, where I lived, and became fascinated, first of all primarily by the classic English landscape artists – Wilson, Constable, Gainsborough, Turner, Palmer – and then especially the English landscape influenced by the Dutch. I remember assiduously copying paintings by Crome. Then I discovered the Dutch originals – perhaps my first fascination with Holland. Then I began to understand the early Impressionist idea of going out and painting in landscapes, so the actual excitement of taking out an easel and paints was itself an event which was entertaining, which I suppose relates to the anecdote of the origins of **The Draughtsman's Contract** fifteen years later. My bird-watching father used to take us regularly to the Suffolk coast – he was attracted to the bird reservation at Minsmere. There were local painting societies at Southwold and Walberswick, and the summer landscapes were dotted by distant people painting in corners of cornfields – reproducing the long Norfolk tradition of obsessives like Algernon Newton, whose regular corners-of-a-

distant-field were shown at the Royal Academy exhibition every summer. And I am sure those retired businessmen-painters made dull paintings under those huge Suffolk skies, but I found the tramping around forgotten water meadows and cornfields romantic. I enjoyed myself. So by the time I was fifteen I could say, at least to myself, *I really do want to be a painter*. And I pursued the idea. My parents thought it was the most crazy and stupid idea. I bypassed a university education and insisted that I went to art school, which was the beginning of the break with everything my family stood for. And there was no true reconciliation ever again. My disappointed family believed I was doing something worthless, and that I could do it in the evenings and at weekends, and on holidays, like those Southwold painters.

England seems to have been more drawn, sketched, painted and photographed than perhaps any other place in the world. The conventional landscape vocabulary has been used up. How else can you portray a landscape, apart from imitating past painting? Land art offered up a way of doing it, it related to my fascination with maps and plans and diagrams and aerial views.

Soon after leaving art school, I was fortunate to discover a stretch of extraordinarily beautiful landscape around the village of Wardour in Wiltshire, between Salisbury and Shaftesbury, where I spent incredibly happy months when my children were very young. The landscape was a powerful incentive. How do I use this extraordinarily beautiful landscape to make images? How can I return something? How can I take something away? There were many drawings made and experiments made, most of them abortive. Conceptually they were fascinating but difficult to carry through. Grandiose ideas of taking an Ordnance Survey map of a very large scale and utilising the cross-grids of the map as locations to plant forty-eight five-inch circumference ball-bearings into the landscape. It was never finished. It needed secretiveness – to go in the middle of the night into a farmer's backyard, or a cow pen, or by day into a wood or a railway siding with a spade and dig a hole a metre deep and bury one of those very heavy ball bearings, and it was only I who

knew it was there. Many of these events related to my understanding of land art at that particular time. But the desire to record the landscape moved quickly on to recording it and fictionalising it on film. In and around Wardour I made the landscape films of **Water Wrackets**, **Windows**, **Vertical Features Remake**, **H is for House**, and many of the anecdotal montages and films-within-films of **The Falls**.

From another direction altogether was a fascination with seventeenth century French landscape gardening. Nature rearranged to make a stage. One of my favourite spots in Europe is Vaux-le-Vicompte, north of Paris – lawns, trees, gravel paths beautifully organised on systems of false perspective to make landscape into a theatrical performance, how the whole of the four-kilometre garden is deliberately raked like a stage to create special viewpoints for observation. Vaux inspired Versailles, and Versailles seems to have inspired landscape architecture all over Europe. I knew refined and sophisticated examples of garden architecture existed before – the gardens at Pompeii interested me perhaps more than the buildings – but the French baroque garden seemed an apotheosis. It was interesting that seventies Land art turned our attention back to what had been done before, to concepts of the landscape maze, artificial land engineering, and those extraordinary Austrian, German and French landscape fortifications around all the major towns, a form of unconscious pre-Land art land art which had either got lost, neglected or misunderstood.

Or not categorised as art. As it might have been in Japan.
Could you say something about your use of collage?

For me I think it has a great deal to do with the notion of quotation. My films are full of quotations, but they have to be reproduced quotations, so Vermeer's **Art of Painting** in **A Zed and Two Noughts** is a reconstruction, incapable of having any part of the original iconic life of the painting. The beauty of collage is that you can bring the magic of an original page, paper, object with you, and incorporate it so it can lend its own life to the whole.

Again, that is something I would have learnt more from the early paintings of Kitaj than from anybody else, in that 1963 Marlborough exhibition that had such an influence on me. How in one picture space he would collage not only all sorts of different material but he himself would make a reproducible sense of collage so there might be five or six different forms of painted or drawn representations on one canvas. Schwitters was a strong personal discovery I made when I was a teenager – his poetry as well as the collages – but l confess now I find the collages less interesting, not assisted by the massive fading and discolouring of the materials he used. I was encouraged by Rauschenberg's collage techniques, especially in his Dante drawings, which I tried to imitate a long time before working on the **TV Dante** series for Channel Four. I especially admired Braque's use of collage techniques, knowing he had an intimate use and knowledge of the house-decorator's vocabulary.

In the collages there is a great sense of personal imagery that no-one's ever going to know about. If I was to show you this (figure 13) we could talk maybe about things to do with steps, stairs, step-ladders, highness and lowness, ascending, descending – and we could examine the text. But here's a ripped postcard image of the many flights of grandiose steps at the bottom of the Victor Emmanuel building in Rome, and I remember the last day of shooting on **The Belly of an Architect** when Andrea Feriol, who was in **A Zed and Two Noughts**, wanted to be in **The Belly of an Architect** and she hired a car and driver, found out exactly where we were filming, here in the Piazza de Venetia, and she drove round and round the roundabout shown here to make sure at least her face in the car was in the film. The postcard fragment was put there largely in remembrance of that event, and partly to reprise the relationship between the film's hero's obsession with steps and grand staircases.

Here again, private information (figure 14). The Piazza del Popolo has four lions situated on the four corners of the central fountain around the obelisk – they've been there for four hundred years, and for four hundred years, since the stone is quite soft, they've been scratched with all manner of graffiti. You can make out the letters H and J, the initials of my daughters' names taken to sit on those lions when they were very young. When I returned to film **Belly of an Architect** ten years later, the letters could still be seen and photographed. A personal mark related to my own history. But that must surely usually be the way with every single image manufactured.

Also collage particularly exposes the problem with intention as a concept. All sorts of things go through artists' heads as they make things, especially by putting lots of different things together in one picture space, all manner of associations. Are these all intentions? In which case, as they are forgotten, they are intentions irretrievable for the artist as well.

True. Yes. I can certainly now look at the films, occasionally look at the paintings, and I don't understand the references any more. They have gone.

The use of scripts goes back a long way. The early films had scripts on screen as well as drawings.

Initially I would write out the script and then something would occur to me, and I would note it down or illustrate it, so I would end up with writing or a scribbled image in the margin. And that became more and more interesting, the two became united, and in some cases the scribbles entirely engulfed the original. Looking at the current script, each scene is written on a separate page. I don't want to carry the whole book around with me, so I take the page with me and wander around with it in my hand or pocket. By the end of the day it's scribbled on and torn and often crumpled. And it goes back into the book again. It's now got a history of a day's use associated with it. So sometimes the script amendments are made in a completely utilitarian way, and sometimes of course the page is more self-consciously played with.

figure 13
The Stairs Page 9 1988
collage on paper, 41 x 31 cm. Collection of the artist.

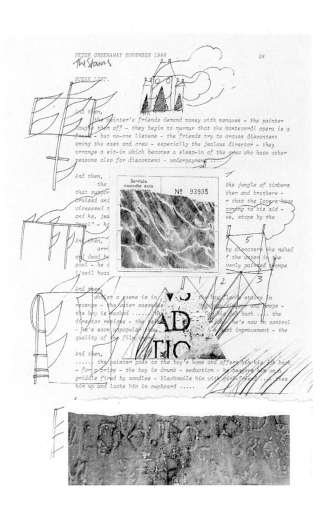

figure 14
The Stairs Q4 1986
collage on paper, 41 x 31 cm. Collection of the artist.

We have I think three times now exhibited the entire worked-over 207 script pages of **Drowning by Numbers**. The ten-week film was shot all over East Anglia, so it's got grass stains, rain marks and bird shit on the pages. They have been ripped and torn, and they have fallen in the water and the ink has run, and there are many different writings on the pages with many different pens in the course of those ten weeks. Apart from extra and self-conscious additions, the script records the passage of the making of the film.

Finally, a lot of the works are quite small in scale – presumably because you are travelling all the time, or away on set, without a studio?

The lack of an ever-prepared permanent work space is also probably one of the reasons I use acrylic. It's fast-drying and makes a tough surface on practically anything. Time is very limited, and painting needs, as you suggest, that sense of distance and contemplation, and it's difficult to find that. What also happens is a high-pressure demand to do it that builds up like water behind a dam. I haven't done any continuous painting for some time – three months, and I am itching to start. The experience of making a film and two operas has set me considering visual alternatives, visual commentaries. But in my luggage you will find the painting materials. It's heavy, and it often leaks on to my shirts. We have a large film-art department and I've been pinching bits of hardboard and canvas from them, and I have a large and expensive hotel room round the corner from this studio, and in the bathroom are some dozen or so half-finished paintings.

When the rub finally comes, and the money runs out, and nobody wants me to make films any more, I would quite happily retire from that whole area of image making and become much more associated with the notion of the mark on the page. In the end I might be just as happy on my own – making investigative stains on paper that cost a few pounds to manufacture rather than movies which cost ten million and involve two thousand people.

CATALOGUE *of* WORKS IN THE EXHIBITION

Measurements are in centimetres, height before width. It should be noted that the authors were unable to verify all measurements and that the titles of the first ten entries were supplied by the authors, not by the artist. All works collection of the artist unless otherwise stated. The ***100 Allegories to Represent the World*** (see plates 84–6) were generated on a computer, and designed to be viewed on a monitor or printed on paper. Unlike the other plates in this book, plates 84–6 are not reproductions but original prints in an edition limited by the run of this publication (3,000). The ***Allegories*** included in the exhibition have been taken from this book.

Nativity Star, 1963
Oil, pencil and collage on hardboard
76.5 x 106.5
[Plate 1] *Not in the exhibition.*

Burnt Holes, 1964
Paper on paper
20 x 29

Computer Vocabulary, 1968
Oil, thread and Letraset on hardboard
Two panels each 122 x 122
[Plate 2]

Stellarscape: Verticals, 1968
Oil on hardboard
Six panels, each 213.5 x 23
[Plate 3]

Stellarscape: Semicircle, 1968
Oil and collage on hardboard
66 x 101
[Plate 4]

Star Grid, 1968
Oil and thread on hardboard
91.5 x 91.5
[Plate 5]

Over-painting Three, 1973
Oil on hardboard
152.5 x 122
[Plate 6]

Landscape Section: Geological Diagram, 1968
Oil on hardboard
40.5 x 53.5
[Plate 7]

Pointillist Relief 1, 1977
Oil on hardboard
85 x 29 x 3.5
[Plate 8]

Pointillist Relief 2, 1977
Oil on hardboard
34.5 x 34 x 13
[Plate 8]

Landscape Section, 1972
Oil, wax, sand and ball bearings on hardboard
122 x 122
[Plate 9]

Gaming Board, 1968
Oil and hinges on wood
approx. 60 x 60
[Plate 10]

Game Board 26, 1970
Mixed media on card
23 x 16

If Only Film Could Do the Same, 1972
Oil and collage on hardboard
25 x 35
[Plate 11]

Red Footballers, 1972
Oil and collage on hardboard
35 x 25
[Plate 12]

Bullworker, 1972
Oil and collage on hardboard
25 x 35
[Plate 13]

The Chinese Wallet I, 1972
Oil and collage on hardboard
35 x 25
[Plate 14]

The Chinese Wallet II, 1972
Oil and collage on hardboard
30 x 22
[Plate 15]

The Chinese Wallet III, 1972
Oil and collage on hardboard
30 x 22
[Plate 16]

The Chinese Wallet IV, 1972
Oil and collage on hardboard
30 x 22
[Plate 17]

Vertical Features Remake: The Research
'Glasbury', 1974
Mixed media on paper
33 x 20
[Plate 18]

Dear Phone 5, 1973
Thread and ink on card
40.5 x 30.5
[Plate 19]

Dear Phone 8, 1973
Ink and wire on card
40.5 x 30.5
[Plate 20]

Dear Phone 9, 1973
Thread and ink on card
40.5 x 30.5
[Plate 21]

Dear Phone (unnumbered), 1973
Ink on paper
40.5 x 30.5
[Plate 22]

A Walk Through H: Robinson Crusoe on
Concrete Island, 1965
Ink on paper
24 x 17
[Plate 23]

A Walk Through H: The Amsterdam Map, 1978
Mixed media on paper
40 x 30
[Plate 24]

A Walk Through H: Who Killed Cock Robin?,
1978
Mixed media on paper
21 x 14
[Plate 25]

A Walk Through H: Thin Cloud over the
Airport, 1976–78
Mixed media on paper
28 x 17.5
[Plate 26]

A Walk Through H: Cross-route, 1976–78
Pencil on paper
18 x 26
[Plate 27]

A Walk Through H: Sweet Bag, 1976–78
Mixed media on paper
21 x 17.5
[Plate 28]

A Walk Through H: Two Small Cities, 1976–78
Mixed media on paper
7.5 x 8, 9.5 x 9
[Plate 29]

A Walk Through H: Sandpaper, 1976–78
Watercolour on sandpaper
10.5 x 12
[Plate 30]

A Walk Through H: Letter R and
the Transparent Score, 1976–78
Mixed media on paper
4 x 5, 8.5 x 6.5

A Walk Through H: Two A Mazes, 1976–78
Watercolour and ink on paper
Overall: 29 x 17

A Walk Through H: A Plan of the Castle,
1976–78
Mixed media on paper
9 x 13

A Walk Through H: A Sentimental Journey,
1976–78
Mixed media on paper
17 x 10.5

A Walk Through H: Encumbered and
Unencumbered, 1976–78
Mixed media on paper
7 x 7, 14.5 x 9.5

A Walk Through H: Four Crosses, 1976–78
Mixed media on paper
13 x 10.5

A Walk Through H: Illustrated Manuscript,
1976–78
Mixed media on paper
15 x 20

A Walk Through H: On Pink Grounds,
1976–78
Mixed media on paper
6.5 x 8, 13.5 x 15.5

A Walk Through H: Part-ride Map, 1976–78
Mixed media on paper
10 x 30

A Walk Through H: Small Red Thread, 1976–78
Mixed media on paper
5 x 5

A Walk Through H: Small Trousers, 1976–78
Mixed media on card
11.5 x 8

A Walk Through H: The Aboukir Bay Map,
1976–78
Mixed media on paper
20 x 14

A Walk Through H: The Black Pyramid,
1976–78
Mixed media on paper
15 x 20

A Walk Through H: The Diplomatic Bag,
1976–78
Mixed media on a brown envelope
25 x 18

A Walk Through H: The Empty Fields, 1976–78
Mixed media on paper
7.5 x 7.5, 19 x 15.5

A Walk Through H: The Great Grey Shrike,
1976–78
Mixed media on paper
25 x 16

A Walk Through H: The Green Cross, 1976–78
Mixed media on paper
14 x 12.5

A Walk Through H: The Low Hoop, 1976–78
Watercolour on paper
8 x 17

A Walk Through H: The Papal Map, 1976–78
Gouache on newsprint
14 x 20

A Walk Through H: The Right Road Lost,
1976–78
Ink and paint on paper
8.5 x 8.5, 9.5 x 10

A Walk Through H: The Salmon Pond, 1976–78
Mixed media on paper
9 x 17

A Walk Through H: Three Cartographical
Tickets, 1976–78
Mixed media on paper
5 x 7.5, 5.5 x 6, 7 x 7

A Walk Through H: Through the Square, 1976–78
Mixed media on paper
10 x 15

A Walk Through H: Verticals, 1976–78
Mixed media on paper
15 x 14

A Walk Through H: Walking Windmills,
1976–78
Mixed media on paper
26 x 13.5

A Walk Through H: White Lane/Blue Hill,
1976–78
Mixed media on paper
13.5 x 12

A Walk Through H: Whither Shall I Wander?
1976–78
Mixed media on paper
15 x 21

A Walk Through H: Yellow Roads, 1976–78
Watercolour on paper
20 x 16.5

100 Windmills: Numbers 16–17, 1978
Mixed media on paper
11 x 10, 13 x 14
[Plate 31]

100 Windmills: Number 7, 1978
Mixed media on paper
14 x 15
[Plate 32]

100 Windmills: Numbers 96–9, 1978
Mixed media on paper
each 12 x 10
[Plate 33]

100 Windmills: Numbers 5–6, 1978
Mixed media on paper
11 x 9.5

100 Windmills: Numbers 11–14, 1978
Mixed media on paper
10.5 x 8.5, 14.5 x 6, 15.5 x 11

100 Windmills: Number 15, 1978
Mixed media on paper
21 x 11

100 Windmills: Numbers 19–21, 1978
Mixed media on paper
19 x 14, 8 x 10, 9.5 x 11.5

100 Windmills: Number 32, 1978
Mixed media on paper
24 x 17

100 Windmills: Numbers 37–40, 1978
Mixed media on paper
each 12 x 10

100 Windmills: Numbers 71–3, 1978
Mixed media on paper
9 x 17

100 Windmills: Numbers 78–82, 1978
Mixed media on paper
23.5 x 16.5

100 Windmills: Numbers 83–4, 1978
Mixed media on paper
8 x 7, 8.5 x 9

100 Windmills: Numbers 85–7, 1978
Mixed media on paper
6 x 7.5, 13 x 15

100 Windmills: Number 91, 1978
Mixed media on paper
16 x 16

100 Windmills: Number 100, 1978
Mixed media on paper
25 x 17.5

100 Windmills: Number 102, 1978
Mixed media on paper
16.5 x 14.5

The Falls: Fallaburr, 1978–80
Collage and mixed media on paper
31 x 41
[Plate 34]

The Falls: Fallabus, 1978
Collage and mixed media on paper
31 x 41
[Plate 35]

The Falls: Fallaby, 1978–80
Collage and mixed media on paper
31 x 41
[Plate 36]

The Falls: Fallacet, 1978–80
Collage and mixed media on paper
31 x 41
[Plate 37]

The Falls: Fallack, 1978–80
Collage and mixed media on paper
31 x 41
[Plate 38]

The Falls: Fallbatts, 1978–80
Collage and mixed media on paper
31 x 41
[Plate 39]

The Post, 1988
Pencil on card
112 x 81
[Plate 40]

Post and Chairs, 1988
Pencil on card
112 x 81
[Plate 41]

McCay's Grid, 1989
Mixed media on paper
112 x 81
[Plate 42]

Frame Catalogue, 1989
Mixed media on paper
81 x 112
[Plate 43]

Pages from 'A Framed Life' 1, 1989
Mixed media on paper
35 x 22
[Plate 44]

Pages from 'A Framed Life' 2, 1989
Mixed media on paper
35 x 22
[Plate 45]

Proportional Representation, 1989
Acrylic on card
81 x 112
[Plate 46]

Twenty-three Corpses, 1989
Acrylic on card
90 x 120
[Plate 47]

Deus ex Machina, 1990
Acrylic on card
112 x 81
[Plate 48]

Blackbird Singing in the Dead of Night, 1990
Acrylic on card
81 x 112
[Plate 49]

55 Men on Horseback: Five by Eleven, 1990
Mixed media on card
81 x 112
[Plate 50]

55 Men on Horseback: Seven by Eight, 1990
Mixed media on card
81 x 112
[Plate 51]

Weighing Horses, 1990
Acrylic on card
81 x 112
[Plate 52]

Bathroom Literature, 1990
Mixed media on card
112 x 81
[Plate 53]

Prospero's Allegories: Night, 1991
Mixed media on paper
29.5 x 21
[Plate 54]

Prospero's Allegories: Night I, 1991
Mixed media on paper
29.5 x 21
[Plate 55]

Prospero's Allegories: Silenus, 1991
Mixed media on paper
29.5 x 21
[Plate 56]

Prospero's Allegories: Simpleton, 1991
Mixed media on paper
29.5 x 21
[Plate 57]

Prospero's Allegories: The Arithmetician, 1991
Mixed media on paper
29.5 x 21
[Plate 58]

Prospero's Allegories: Vulcan, 1991
Mixed media on paper
29.5 x 21
[Plate 59]

Prospero's Allegories: Callisto, 1991
Mixed media on paper
29.5 x 21

Prospero's Allegories: Spinner, 1991
Mixed media on paper
29.5 x 21

Prospero's Allegories: The Keeper of
Forbidden Books, 1991
Mixed media on paper
29.5 x 21

The Audience of Mâcon 3, 1992
Photograph and text on card
66 x 45
Private collection [Plate 60]

The Audience of Mâcon 4, 1992
Photograph and text on card
66 x 45
Private collection [Plate 61]

The Audience of Mâcon 6, 1992
Photograph and text on card
66 x 45
Private collection [Plate 62]

The Audience of Mâcon 7, 1992
Photograph and text on card
66 x 45
Private collection [Plate 63]

The Audience of Mâcon 36, 1992
Photograph and text on card
66 x 45
Private collection [Plate 64]

The Audience of Mâcon 100, 1992
Photograph and text on card
66 x 45
Private collection [Plate 65]

The Audience: Text Faces, 1993
Acrylic on card
81 x 112
[Plate 66]

The Audience: The Scholars, 1993
Acrylic on card
81 x 112
[Plate 67]

The Audience: The Cast I First Thought Of,
1993
Acrylic on card
81 x 112
[Plate 68]

The Audience: Looking for a Small Cast
(Black 4), 1993
Acrylic on card
81 x 112
[Plate 69]

The Audience: Red Twins, 1993
Mixed media on card
81 x 112
[Plate 70]

Head Text Series, 1994
A–Z, except for J, K, O, T, U, V, Z
Mixed media on paper
29.5 x 21
[Plates 71–9, A, B, D, E, F, N, Q, R, W respectively]

A Short Frame Résumé, 1994
Mixed media on card
85 x 74
[Plate 80]

Byzantium, 1994
Mixed media on card
85 x 116
[Plate 81]

Schweeger's Frames, 1994
Mixed media on card
85 x 116
[Plate 82]

To the Millenium, 1994
Mixed media on card
85 x 116
[Plate 83]

100 Allegories to Represent the World:
Number 33 – Future, 1996
Litho four-colour process print on paper
15.5 x 10.5
[Plate 84]

100 Allegories to Represent the World:
Number 81 – Icarus, 1996
Litho four-colour process print on paper
15.5 x 10.5
[Plate 85]

100 Allegories to Represent the World:
Number 93 – Marat, 1996
Litho four-colour process print on paper
15.5 x 10.5
[Plate 86]

In the Dark: Sad Nose Text, 1996
Collage on paper
29 x 23
[Plate 87]

In the Dark: Audience, 1996
Collage on paper
38.5 x 33
[Plate 88]

In the Dark: Child Actors, 1996
Collage on paper
38.5 x 33
[Plate 89]

In the Dark: Hydrobiology, 1996
Collage on paper
29 x 23
[Plate 90]

Some Very Low Temperatures, 1997
Acrylic on board
109 x 122
[Plate 91]

Moving Towards Safety, 1997
Mixed media on card
70 x 81
[Plate 92]

Old Water, 1997
Mixed media on card
63.5 x 68.5
[Plate 93]

Icarus Falling into Water, 1997
Mixed media on card
109 x 122
[Plate 94]

Choosing a Colour for Rosa's Blood, 1997
Mixed media on hardboard
103.5 x 82
[Plate 95]

Half Woman, 1998
Acrylic on hardboard
94 x 64
[Plate 96]

BIBLIOGRAPHY

The items in this bibliography are divided into five sections. Square brackets indicate that the author was unable to verify information. **Curated exhibitions, installations, solo and group exhibitions**: this list aims to be comprehensive, although there are bound to be omissions. Where a catalogue was published, full bibliographical details are given, if known. For shows that toured, some indication of the itinerary is given. Entries are listed in chronological order. **Filmography**: this listing of films or videos directed by the artist since 1966 aims to be comprehensive. However, the author was unable to trace those films from 1959 and 1965 to which Greenaway alludes in an annotated filmography for *Film Comment*. To make this section as useful as possible, descriptions of the artist's short films have been included. In order to keep the section to manageable proportions, cast and production details from the artist's feature films have been omitted: this information is readily available from a variety of sources, including the published scripts and the notes which accompany their release on video. Entries are listed chronologically and the following abbreviations are employed. C: camera / DM: dubbing mixer / E: editor / M: music / N: narrator / P: producer / S: sound / SC: script. **Musicography**: a listing of operas directed by Greenaway in chronological order. **Books and portions of books**: this includes books by and about the artist, entries are listed alphabetically by author. **Articles in Periodicals**: the sheer volume of material and the slight nature of much of it has resulted in an extremely selective listing of articles with a bias towards English-language, fine art publications. Entries are listed chronologically.

1964
London, Lord's Gallery. [*Eisenstein at the Winter Palace.*] Solo exhibition.

1976
London, Arts 38. [Solo exhibition.]

London, Curwen Gallery. [Solo exhibition.]

1982
Edinburgh, The Talbot Rice Art Centre. *Plans and Conceits...'of doubtful authenticity'...* . Solo exhibition. Catalogue published by the British Film Institute, London. Text by the artist, Tony Rayns, Mary Jane Walsh. 20 August – 11 September.

1988
Canterbury, Broad Street Gallery. [Set designs.] Solo exhibition.

1989
New York, Nicole Klagsbrun Gallery. *Greg Colson, Peter Greenaway, Nicolas Rule.* Group exhibition. No catalogue. [?] November – 23 December.

Belgrade, Students' Cultural Centre. *Peter Greenaway: Drawings and Collages.* Solo exhibition. Catalogue published in association with the British Council. Text by the artist and Nikola Suica. 3–12 November.

Carcassonne, Arcade. Solo exhibition.

Paris, Centre National des Arts Plastiques. Group exhibition.

Paris, Palais de Tokyo. Solo exhibition.

1990
New York, Nicole Klagsbrun Gallery. *Peter Greenaway: Paintings, Collages, Drawings and Videos.* Solo exhibition. No catalogue. 17 February – 8 March.

Melbourne, Australia Center of Contemporary Art. *Peter Greenaway's Private Speculations:*

Drawings and Sketches for his Films with Costumes by Jean-Paul Gaultier. 21 February – 4 March. Travelling to City Art Institute (Sydney), and Ivan Dougherty Gallery (University of New South Wales, Paddington), 22–31 March. Duplicated typescript with text by Greenaway.

Munich, Dany Keller Galerie. *Zeichnungen, Collagen, Video.* Solo exhibition. No catalogue. 27 July – 4 August.

Brussels, Galerie Xavier Hufkens. No catalogue.

Copenhagen, Video Gallery.

Fukuoka, Altium.

Liège, Cirque Divers. No catalogue.

Oddense (Denmark), Kunsthallen Brandts Klaedefabrick.

Tokyo, Shingawa Space T33.

1991
Brentford, Watermans Arts Centre. *If Only Film Could do the Same.* Solo exhibition (works from 1972 to 1990). No catalogue. 21 June – 28 July.

Dublin, City Art Centre. [*Peter Greenaway*]. Solo exhibition. No catalogue. October. [Touring exhibition.]

1992
New York, Nicole Klagsbrun Gallery. *Prospero's Creatures.* Solo exhibition. No catalogue. 4–25 January.

Bremen, Gesellschaft für Aktuelle Kunst. *Prospero's [Creatures / Books].* Solo exhibition. No catalogue. 22 March – 3 May.

Vienna, Academy of Fine Arts. *Hundert Objekte zeigen die Welt – 100 Objects to Represent the World.* Curated exhibition / installation. Catalogue published by Verlag Gerd Hatje, Stuttgart. 1 October – 8 November.

Rotterdam, Museum Boymans-van Beuningen. *The Physical Self.* Curated exhibition. Text by the artist. 27 October – 12 January 1993.

Paris, The Louvre. *Le Bruit des Nuages – Flying out of this World.* Curated exhibition. Text by the artist. Catalogue published by Réunion des Musées Nationaux, Paris. Reprinted 1994 as *Flying out of this World,* University of Chicago Press, Chicago and London. 3 November – 1 February 1993.

1993
Venice, Palazzo Fortuny. *Watching Water.* Installation. Catalogue published by Electa, Milan. Text by the artist. 12 June – 12 September.

Swansea, Glynn Vivian Art Gallery. *Some Organising Principles – Rhai Egwyddorion Trefn.* Curated exhibition. Catalogue published in association with the Wales Film Council. Text by the artist. 2 October – 21 November.

Cardiff, Ffotogallery. *The Audience of Mâcon.* Solo exhibition. Text by the artist. 16 October – 20 November.

1994
Geneva. *The Stairs 1: The Location.* City-wide installation. Catalogue published by Merrell Holberton, London. Text by the artist. Includes CD of music by Patrick Mimran. 30 April – 1 August.

Arizona, Arizona State University Art Museum. *Peter Greenaway: If Only Film Could Do the Same.* Solo exhibition. Six-page typescript with text by Heather Sealy Lineberry and statement by the artist. 7 October – 15 January 1995.

Salzburg, Gesellschaft für Max Reinhardt-Forschung. *Shakespeare in Film.* Group exhibition.

1995
Munich. *The Stairs 2: Projection.* City-wide installation. Catalogue published by Merrell Holberton, London. Text by the artist. 26 October – 19 November.

New York, Nicole Klagsbrun Gallery. *The World of Peter Greenaway*. Solo exhibition. No catalogue. 9–22 November.

New York, Nicole Klagsbrun Gallery. *Selections from 1989 to 1995*. Group exhibition (thirty-two other contributors). No catalogue. 9–22 November.

Munich, Dany Keller Galerie. *Bilder zu "Stairs 2: Projection-Frames"*. Solo exhibition. No catalogue. 7–16 December.

Biel-Bienne (Switzerland), Centre PasquART. *Artistes – Cineastes/Filmemacher Künstler*. Group exhibition.

1996

Oxford, Museum of Modern Art. *The Director's Eye: Drawings and Photographs by European Film-makers*. Group exhibition (fifty-four other contributors). Travelling to York, Rye, Hartlepool, Osaka, Tokyo. Text by David Elliott, Ian Christie. 17 February – 14 April.

London, Hayward Gallery. *Spellbound: Art and Film*. Group exhibition (nine other contributors). Greenaway contributed 'In the Dark', an installation. Catalogue published by British Film Institute, London, ed. Ian Christie and Philip Dodd. 22 February – 6 May.

London, Lamont Gallery. *Freezeframe*. Group exhibition (thirteen other contributors). Greenaway contributed four paintings. No catalogue. 26 April – 26 May.

Rome, Piazza del Popolo. *Cosmology at the Piazza del Popolo: a history of the Piazza from Nero to Fellini using light and sound*. Installation. [No catalogue.] 23–30 June.

Ghent, Galerie Fortlaan 17. *The Tyranny of the Frame*. Solo exhibition. No catalogue. 25 September – 27 October.

Thessaloniki, Mylos Art Gallery. *Peter Greenaway: Paintings, Drawings, Collages*. Solo exhibition. Text by the artist, Dimitri Eipides, Christos Kallitsis. 7–24 November. [Travelling to Istanbul Film Festival and Doong Soong Art Centre, Korea.]

Milan, Le Case d'Arte. *The World of Peter Greenaway*. Solo exhibition. [No catalogue.]

1997

Barcelona, Fundació Joan Miró. *Flying over Water*. Curated exhibition / installation. Catalogue published in association with Merrell Holberton, London. Text by the artist. 6 March – 25 May.

Mexico City, Museo Rufino Tamayo Contemporaneo Internacional. *Film and Painting: Places and Artifice*. Solo exhibition. Text by Magali Arriola, David Huerta, Maria Virginia Jaua. 15 June – 28 September. Travelling to Centro Cultural Banco do Brasil (Rio de Janeiro), 10 July – 20 September 1998, and Sesc Villa Mariana (São Paulo), 14 July – 17 August 1998.

FILMOGRAPHY

Train
1966 / 16 mm / bw / approx. 5'. A mechanical ballet composed of footage of the last steam trains arriving at Waterloo Station [edited to, or with, a *musique concrete* score].

Tree
1966 / 16 mm / bw / [approx. 5']. The tree is a wych elm next to the Royal Festival Hall on London's South Bank Centre. This five-part film is edited to Anton Webern's *Five Pieces for Orchestra* (1913), and is the film shown within biography 83 of Greenaway's 1980 film, *The Falls*.

5 Postcards from Capital Cities
1967 / 16 mm / bw / approx. 35'. 'featuring the five very different ports of Rotterdam, Amsterdam, Goole, London and Newport.' Peter Greenaway in *Flying over Water*, ex. cat., Barcelona, Foundació Joan Miró, 1997, p. 92.

Revolution
1968 / 16 mm / bw / 3'15". M: The Beatles. Film of a demonstration through central London. Kenneth Tynan is among those marching. Edited to the Beatles' *Revolution* (1968).

Intervals
1969 / 16 mm / bw / 6' / [sound added October 1973]. M: Vivaldi. Filmed over the winter of 1968–69 by the canals of Venice (although water is only glimpsed), fifteen sections of film – one of 13.5 seconds duration, the others of 6.5 seconds – are separated by a 0.5 second interval and shown three times in the same order. Other forms of repetition are also employed. The sound track begins with the beat of a metronome to which are added a variety of urban sounds – often tied to a particular motif – and a basic lesson in Italian that includes the correct way to prounounce the letters of the alphabet. The film concludes with an excerpt from the 'Winter' movement of Vivaldi's *Four Seasons* (1730).

Erosion
1971 / 16 mm / bw / approx. 25'. 'I tried to find the filmable evidence of the land eroding – seashores, rock faces crumbling – and put it together with the oldest rocks first and the most recent last.' Greenaway in Steinmetz and Greenaway (1995) p. 3. 'An early film called *Erosion*, filmed in Western Ireland in 1971, featured a number of dog-corpses washed up on beaches or thrown over cliffs.' Greenaway in Lawrence, A. (1997) p. 204, n. 42.

H is for House
1973, re-edited 1978 / 16 mm / colour / 8'45". M: Vivaldi, Rameau. N: Colin Cantlie, Peter Greenaway, Hannah Greenaway. Containing three short stories narrated by Greenaway as well as precise information on the appearance and nesting habits of some common birds. The principal narrator of this film (which resembles a home movie and was shot in the grounds of a house in Wardour on the Wiltshire–Dorset border) lists groups of words that begin with the letter H. The first group are all words which refer to parts of the human body. The majority, however, have nothing in common except their initial letter. The listing, far from being a means of ordering the world, becomes little more than a babble, the outpourings of a repetitive and obsessional mind. It has the loquaciousness of the speech of children and is fittingly juxtaposed with Greenaway's young daughter's attempts to order the world through the correct pronunciation of the letters of the alphabet and a few simple words.

Windows
1975 / 16 mm / colour / 3'30". M: Rameau. N:
Peter Greenaway. An idyllic landscape seen
through the windows of a house – the same as
that featured in *H is for House* – is juxtaposed
with a collection of statistics concerning the
thirty-seven people who died by jumping, or by
being pushed, out of windows in the parish of
'W' during 1973. Edited to Rameau's *The Hen*
(1731).

Water
1975 / 16 mm / colour / approx. 5'. M: Max
Eastley. 'There was a film simply called *Water*,
containing exactly one thousand images of water,
and shot languidly and pleasurably in the
delightful landscapes of the Welsh Brecon
Beacons, to appreciate the sheer entertainment
of sun on water.' Peter Greenaway in *Flying over
Water*, ex. cat., Barcelona, Foundació Joan Miró,
1997, p. 93. An excerpt is shown in biography 18
of *The Falls* (1980).

Water Wrackets
1975 / 16 mm / colour / 11'15". N: Colin Cantlie.
M: Max Eastley. DM: Tony Anscombe. Filmed
along the river Nadder and the nearby lakes of
Hog, Pole, Pale, Basset and Horridor in Wiltshire.
A series of water surfaces are juxtaposed with a
documentary-style voice-over that recounts the
trivial events, mundane descriptions and
'historical moments' of a military campaign.

Goole by Numbers
1976 / 16 mm / colour / approx . 40'. [Shots of
numerals edited together.]

Dear Phone
1977 / 16 mm / colour / 16'45". N: Peter
Greenaway. The unheeded ringing of public
telephones – shot with a static camera at a
variety of locations and times of the day – is
juxtaposed with biographies of, and accounts of
the relationships between, individuals whose
initials are H.C. The narrative is delivered by
voice-over and by means of images of the actual
script – handwritten, heavily scored and often
illegible.

1-100
1978 / 16 mm / colour / approx. 4'. M: Michael
Nyman . The numerals one to a hundred, shot in
an assortment of contexts in Berlin, Paris, Rome,
Florence and Brussels, and edited in sequence.
Greenaway's first collaboration with Nyman.

*A Walk Through H: The Reincarnation of an
Ornithologist*
1978 / 16 mm / colour / 40'30". British Film
Institute (BFI). N: Colin Cantlie. M: Michael
Nyman. C: John Rosenberg. Rostrum C: Bert
Walker. DM: Tony Anscombe. Tulse Luper has
selected ninety-two maps and collated them in a
unique order to enable an ornithologist to
commence his final journey: a walk and, for a
short time, a run through the country of 'H'.
Details of the 'maps' (made by Greenaway) are
intercut with documentary footage of birds in
their natural habitat and overlaid with the
spoken observations and recollections of the
ornithologist. Perhaps the birds are a metaphor
for the soul, and their migration one for
transmigration?

Vertical Features Remake
1978 / 16 mm / colour / 44'. Arts Council of
Great Britain. N: Colin Cantlie. M: Michael
Nyman. Additional M: Brian Eno. Rostrum C:
Bert Walker. DM: Tony Anscombe. A mock
documentary on the attempts by rival academics
to remake an incomplete and largely missing
film by Tulse Luper thought to list all the
verticals (poles, posts, tree trunks, for example)
in a threatened domestic landscape. The four
remakes organise the vertical features according
to different arithmetical progressions,
progressions which also inform Nyman's score.
In between each remake we are given details of
Luper, his associates, the Institute of
Reclamation and Restoration, and the project for
a New Physical World.

This Week in Britain: Eddie Kidd
1978 / 16 mm / colour / 5'. Central Office of
Information (COI). Filmed at Beaulieu, interviews
with the motorcyclist are edited with stunt jumps
and pictures of the crowd: Ed 'Stewpot' Stewart
(the former Radio One DJ) is master of
ceremonies. Emphasis is placed on the number
of vehicles Kidd jumps across and one passage

shows a rapid succession of numerals. This COI
series – for which Greenaway directed six films –
was designed to provide an entertaining account
of newsworthy people and events.

This Week in Britain: Cut above the Rest
1978 / 16 mm / colour / approx. 5'. COI. Footage
of clothing being made and modelled in Savile
Row is edited to a fast and hard cutting tempo.
Featuring Mick Jagger.

This Week in Britain: Women Artists
1979 / 16 mm / colour / approx .5'. COI. When
women constitute half of the art student
population why are only 4 per cent of
professional artists women? This topic is
discussed during a viewing of an exhibition in
London of paintings by two Australian women
artists.

This Week in Britain: Leeds Castle
1979 / 16 mm / colour / approx. 5'. COI. Film
of preparations for, and highlights of, an event
at Leeds Castle, Kent, organised to promote
British industry. Princess Margaret is the guest
of honour.

Insight: Zandra Rhodes
1979 / 16 mm / colour / 14'. COI. C: John
Rosenberg. S: Dave Lawton. E: John Wilson. P:
Annabel Olivier-Wright. Interviews with the
British fashion designer and her staff are shown
alongside the design and production of
garments, modelled in a railway station. Features
Andrew Logan.

This Week in Britain: Lacock Village
1980 / 16 mm / colour / approx. 5'. COI.

This Week in Britain: Country Diary
1980 / 16 mm / colour / approx. 5'. COI.

The Falls
1980 / 16mm / colour / approx 185'. BFI. E, SC:
Peter Greenaway. Rostrum C: Bert Walker.
Photography: Mike Coles, John Rosenberg. M:
Michael Nyman. Additional M: Brian Eno, John
Hyde, Keith Pendlebury. Films, photographs,
slides and a profusion of narrative and film-
making techniques are employed to produce a
mock documentary concerning the Violent

Unknown Event, the script being based on ninety-two of the 19 million case-histories listed in the 'Directory'. The case-histories chosen – all of victims whose surnames begin with the letters FALL – are placed end to end in alphabetical order. The sections are a compendium of bird lore and also contain a disparate collection of facts, apocrypha, fictions, anecdotes, unfinished and finished films, as well as ideas, motifs and fragments developed by Greenaway in subsequent projects. There is no mistaking that you are watching a film: perhaps you are only watching a film of a film.

Act of God: Some Lightning Experiences 1966–1980
1981 / 16 mm / colour / 26'30". Thames Television. SC: Peter Greenaway. C: Peter George. S: Trevor Hunter. DM: Freddie Slade. E: Andy Watmore. P: Udi Eichler. M: Michael Nyman. Once again, a range of narrative and film-making techniques are employed to produce a documentary which presents the case histories of people who survived yet another violent event, this time an act of God.

Insight: Terence Conran
1981 / 16 mm / colour / 14'. COI. SC: Malcolm Brook. C: Mike Coles, John Rosenberg. S: Malcolm Stewart, Terry Lucas, Chris Moore. E: John Wilson. M: Michael Nyman. P: Annabel Olivier-Wright. Interviews with the British designer and his colleagues are combined with shots of the interiors of his office and shops. Of note is the fast editing to Nyman's music of footage showing shopping baskets being lifted and pages of the Habitat catalogue being turned.

The Draughtsman's Contract
1982 / super 16 mm / colour /108'. BFI in association with Film on Four.

The Sea in their Blood (sometimes referred to as *The Coastline*)
1983 / 16 mm / colour / 26'30". COI. C: John Rosenberg, Mike Coles, Keith Taylor. E: John Wilson. M: Michael Nyman. P: Annabel Olivier-Wright. Film of the British coastline is combined with photographs, slides and text to provide an astonishing catalogue of statistics, facts and anecdotes concerning floral, marine, bird, animal and human life around the British coast.

Four American Composers: Robert Ashley, John Cage, Philip Glass, Meredith Monk
1983 / 16 mm / colour / 4 x 55'. Channel Four Television / Transatlantic Films. P: Revel Guest. Photography: Curtis Clark. E: John Wilson. Based on the Almeida Concerts of September 1982.

Making a Splash
1984 / 16 mm / colour / 24'. Media Software International / Mecca Leisure Productions / Channel Four Television. Underwater C: Michel Gemell. Location C: Mike Coles. Special Effects C: David Spears. E: John Wilson. P: Pat Marshall. M: Michael Nyman. Shots of fish, insects and mammals in or on water lead to a non-verbal account of the increasingly complex social activities enjoyed by humans in swimming pools, culminating in a lengthy demonstration of synchronised swimming.

Inside Rooms: 26 Bathrooms (London and Oxfordshire)
1985 / 16 mm / colour / 25'. Channel Four Television / Artifax Productions. SC: Peter Greenaway. P: Sophie Balhetchet. E: John Wilson. Photography: Mike Coles. M: Michael Nyman. An A–Z of bathrooms.

A TV Dante, Canto 5
1985 / colour / 10'. Co-director: Tom Phillips. Pilot for *A TV Dante* (1989).

A Zed and Two Noughts
1985 / colour / 115'. BFI / Allarts Enterprises / Artificial Eye / Film on Four International.

The Belly of an Architect
1986 / colour / 118'. Callender Company / Film Four International / British Screen / Sacis / Hemdale.

Drowning by Numbers
1988 / colour / 119'. Allarts Enterprises / Film Four International / Elsevier Vendex Film.

Fear of Drowning
1988 / colour / 30'. Allarts Enterprises / Channel Four Television. SC: Peter Greenaway. P: Paul Trybits. Co-director: Vanni Corbellini. A documentary on the making of *Drowning by Numbers*.

Death in the Seine
1989 / colour / 44'. Erato Films / Allarts TV Productions / Mikros Image / La Sept. Director of Photography: Jean Penzer. C: Chris Renson. S: Gert Jan Eylers. Production Design: Ben Van Os. Infography: Eve Ramboz. M: Michael Nyman. To celebrate the bicentenary of the French Revolution, the descriptions of 23 corpses taken from a mortuary archive in the Bibliothèque Nationale are examined and used to commemorate the other 283 bodies dragged from the river Seine by two morgue assistants between April 1795 and September 1801 – years that include the Terror, the Directoire and the Consulate.

The Cook, the Thief, his Wife and her Lover
1989 / colour /120'. Allarts Enterprises / Erato Films / Films Inc.

Hubert Bals Handshake
1989 / colour / 5'. Allarts Enterprises for the Rotterdam Film Festival. Memorial to Hubert Bals, former director of the Rotterdam Film Festival.

A TV Dante Cantos 1-8
1989 / colour / 8 x 10'. KGP Production in association with VPRO / Elsevier Vendex Film / Channel Four Television. Co-director: Tom Phillips. E: John Wilson. Video Post Production: Bill Saint. A commentary on the making of the series and the content of each episode is provided by Tom Phillips, see 'Books and portions of books'.

Prospero's Books
1991 / colour / 123'. Allarts / Cinea / Camera One / Penta Film / Elsevier / Vendex Film / Film Four International / VPRO / Canal / NHK.

M is for Man, Music and Mozart
1991 / colour / 29'. BBC / AVRO / Artifax. SC:
Peter Greenaway. P: Annette Moreau. Production
Design: Jan Roelfs. M: Louis Andriessen.
Produced for the telelvision series *Not Mozart*.

A Walk through Prospero's Library
1992 / colour / 22'45". An Intervall Production.
N: Peter Greenaway. M: Philip Glass. P: Thomas
W. Klinger. Calligraphy: Brody Neuenschwander.
Video E: Achim Seide. Video Production: Voss &
Partners, TV Ateliers. A treatment of the three-
and-a-half-minute passage from the opening of
Prospero's Books which shows Prospero walking
through his library past 100 historical,
mythological and fictional characters.

Darwin
1992 / colour / 52'30". Telemax Les Editions
Audiovisuelles in association with Antennae 2 /
Channel Four / RAI 2 / Telepool / Time Warner.
Director of Photography: Chris Renson and Reinier
van Brummelen. M: Nicholas Wilson. E: Chris Wyatt.
P: Kees Kasander. A consideration of the life and
work of Charles Darwin in eighteen tableaux.

Rosa
1992 / 70 mm /bw /15'30". La Monnaie de Munt
/ Rosas Production. Director of photography:
Sacha Vierny. C: Chris Renson. E: Chris Wyatt.
S: Bert Koops. M: Bela Bartok. Dance based on
choreography by Anne Teresa de Keersmaeker in
collaboration with Jean-Luc Ducourt. Filmed in
the rotunda of the Ghent Opera House.

The Baby of Mâcon
1993 / colour /120'. Allarts Enterprises / UGC–La
Sept / Cine / Electra II / Channel Four Television
/ Filmstiftung / Nordrhein-Westfälen / Canal.

The Stairs, Geneva
1994 / colour / 100'. Apsara Production. M:
Patrick Mimran. N: Peter Greenaway. Film of
Greenaway's city-wide installation *The Stairs* in
Geneva.

The Pillow Book
1995 / colour / 123'. Kasander & Wigman,
Woodline Films, Alpha Films, Channel Four
Films, Studio Canal, Delux Productions.

La Cosmologia di Piazzo del Popolo
1996 / colour / 14'. Acea. N: Peter Greenaway.
M: Patrick Mimran. C: Massimo Zanirato. E:
Simone Carrarcsi. Film of Greenaway's light
show. See 'Exhibitions', 1996.

Bridge Celebration
1997 / colour / [12'] / [Rotterdam Film Festival].
'Rotterdam celebrates a new bridge connecting
the old city and the new. This film is a
celebration of that event – remembering that [the
Dutch documentary film maker] Joris Ivens made
such a film for Rotterdam on another bridge in
1932.' Peter Greenaway in a note to the author.

MUSICOGRAPHY

M is for Man, Music and Mozart.
1991 / 30'. Libretto and direction: Peter
Greenaway, except libretto for 'The Alphabet
Song', Louis Andriessen and Jeroen van der
Linden. Music: Louis Andriessen. Commissioned
for the Mozart Bicentennial celebrations.

Rosa: A Horse Drama.
1994 / 80' / Opera in twelve scenes. Libretto
and direction: Peter Greenaway. Music: Louis
Andriessen. Premiered: Musiektheater,
Amsterdam.

*100 Objects to Represent the World:
A Prop-Opera.*
1997 / approx. 65'. Libretto and direction:
Peter Greenaway. Music: Jean-Baptiste Barrie.
Premiered: Zeitfluss Festival, Salzburg.

Christopher Columbus
1998. Direction: Peter Greenaway. Music: Darius
Milhaud. Libretto: Paul Claudel. Premiered:
Staatsoper Berlin.

Also of note is the Halfer Trio's *One dozen
ecomomical stories by Peter Greenaway –
corrupted, manipulated and accompanied by
the Halfer Trio.* Sub Rosa, Distribution:
Southern Record Distribution Company SR71,
1994. Three of these stories are recited in *H is
for House* (see 'Filmography').

BOOKS AND PORTIONS OF BOOKS

Barchfeld, C. (1993) *Filming by Numbers: Peter
Greenaway. Ein Regisseur zwischen
Experimentalkino und Erzählkino* Gunter Narr
Verlag, Tübingen.

Bencivenni, A. and Samueli, A. (1996) *Peter
Greenaway, il cinema delle idee* Recco, Genoa.

Berthin-Scaillet, A. (1992) *Peter Greenaway:
fête et défaite du corps* L'Avant-scène Cinéma
(special issue), Paris.

Bogani, G. (1995) *Peter Greenaway* Editrice Il
Castoro, Milan.

Caux, D., Feild, M., Meredieu, F. de, Pilard, P.
(1987) *Peter Greenaway* Dis Voir, Paris; (1992)
Filmstellen VSETH/VSU, Zurich. Includes
interview with Michael Nyman.

Cixous, H. and others (1990) *Karine Saporta,
Peter Greenaway: roman photo* Armand Colin,
Paris. Interview with the artist in French.

Cowie, E. ed. (1978) *Catalogue British Film
Institute Productions 1977-1978* British Film
Institute, London. Contains notes on *A Walk
Through H* by Peter Sainsbury, Peter Greenaway
and Michael Nyman.

Denham, L. (1993) *The Films of Peter
Greenaway* Minerva Press, London.

Elliott, B. and Purdy, A. (1992) 'Artificial
Eye/Artificial You: Getting Greenaway or
Mything the Point?' in Purdy, ed. (1992)
Literature and the Body Rodopi, Amsterdam.

Elliott, B. and Purdy, A. (1997) *Peter Greenaway:
Architecture and Allegory* Academy Editions,
Chichester.

Frommer, K. (1994) *Inszenierte Anthropologie.
Asthetische Wirkungsstrukturen in Filmwerk
Peter Greenaways* Cologne.

Gaetano, D. de (1995) *Il cinema di Peter
Greenaway* Lindau, Turin.

Gielgud, J. and Miller, J. (1991) *Shakespeare: Hit or Miss?* Sidgwick & Jackson, London.

Gorostiza, J. (1995) *Peter Greenaway* Ediciones Catedra, Madrid.

Greenaway, P. (1984) *The Draughtman's Contract. L'Avant-scène Cinéma* (special issue), Paris.

Greenaway, P. (1986) *A Zed and Two Noughts* Faber & Faber, London; repr. 1998, Dis Voir, Paris.

Greenaway, P. (1987) *The Belly of an Architect* Faber & Faber, London; Haffmans Verlag, Zurich; repr. 1998, Dis Voir, Paris.

Greenaway, P. (1988) *Drowning By Numbers* Faber & Faber, London; repr. 1998, Dis Voir, Paris.

Greenaway, P. (1989) *Fear of Drowning: Règles du Jeu* Dis Voir, Paris.

Greenaway, P. (1989) *The Cook, the Thief, his Wife and her Lover* Dis Voir, Paris; Haffmans Verlag, Zurich.

Greenaway, P. (1990) *Papers – Papiers* Dis Voir, Paris.

Greenaway, P. (1991) *Prospero's Books: a Film of Shakespeare's 'The Tempest'* Chatto & Windus, London; Haffmans Verlag, Zurich.

Greenaway, P. (1992) *Prospero's Subjects* Yoshiba & Co, Tokyo.

Greenaway, P. (1993) *Rosa* Dis Voir, Paris.

Greenaway, P. (1993) *The Falls* Dis Voir, Paris; 1994, Editrice Il Castoro, Milan.

Greenaway, P. (1993) *The Baby of Mâcon* Rogner & Bernhard, Hamburg; 1994, Dis Voir, Paris.

Greenaway, P. (1996) *The Pillow Book* Dis Voir, Paris.

Hacker, J. and Price, D. (1991) *Take Ten: Contemporary British Film Directors* Oxford University Press, Oxford.

Kremer, D. (1995) *Peter Greenaways Filme. Vom überleben der Bilder und Bücher* Metzler, Stuggart and Weimar.

Lawrence, A. (1997) *The Films of Peter Greenaway* Cambridge University Press, Cambridge.

Lüdeke, J. (1996) *Die Schönheit des Schrecklichen. Peter Greenaway und seine Filme* Bastei-Lübbe-Taschenbuch, Bergisch Gladbach.

Massimo Chirivi, M. (1991) *Peter Greenaway* Circuito Cinema.

Park, J. (1984) *Learning to Dream: The New British Cinema* Faber & Faber, London.

Pascoe, D. (1997) *Peter Greenaway: Museums and Moving Images* Reaktion Books, London.

Peucker, B. (1995) *Incorporating Images: Film and the Rival Arts* Princeton University Press, Princeton.

Phillips, T. (1990) *A TV Dante* Channel Four Television in association with the Talfourd Press, London.

Reddish, L. ed. (c. 1992) *The Early Films of Peter Greenaway* British Film Institute, London.

Rowe, C. (1993) 'Dominating Peter Greenaway' in Kroker, A. and Kroker, M. K. *The Last Sex: Feminism and Outlaw Bodies* St Martin's Press, New York.

Santagostino, R. (1994) *Appuntamento Greenaway* Circolo del Cinema Italiano.

Scura, C. (1995) *Peter Greenaway* Dino Audino Editore.

Steinmetz, L. and Greenaway, P. (1995) *The World of Peter Greenaway* Charles Tuttle Co, Boston.

Stoneman, R. and Thompson, H. ed. (1981) *The New Social Function of Cinema: Catalogue of British Film Institute Productions 79/80* British Film Institute, London. Contains Greenaway's notes on *The Falls* and a comment by Simon Field.

Thau, C. and Troelsen, A. (1996) *Filmen Som Verdensteater – omkring Peter Greenway* Forlaget Klim, Arhus.

Walker, J. A. (1993) *Art and Artists on Screen* Manchester University Press, Manchester.

Walsh, M. (1993) 'Allegories of Thatcherism: The Films of Peter Greenaway' in Friedman, L. ed. (1993) *Fires were Started: British Cinema and Thatcherism* University of Minnesota Press, Minneapolis. See also the chapter by Peter Wollen.

Woods, A. (1996) *Being Naked, Playing Dead: The Art of Peter Greenaway* Manchester University Press, Manchester.

ARTICLES IN PERIODICALS

1978
Pulleine, T. (Review of *A Walk through H*), *Monthly Film Bulletin* (September).

1979
Andrews, N. 'A Walk Through Greenaway', *Sight and Sound* (spring). Interview.

1981
Auty, C. 'The Birds' (review of *The Falls*), *Sight and Sound* (spring).

Auty, C. 'Best Laid Plans...', *City Limits* (30 October – 5 November). Interview.

Forbes, J. (Review of *The Falls*), *Monthly Film Bulletin* (January).

Hodge, A. '1694 Labour of Love Completes BFI Trio: Adrian Hodges talks to new director Peter Greenaway', *Screen International* (December).

Pym, J. (Review of *Vertical Features Remake*), *Monthly Film Bulletin* (January).

1982
Brown, R. (Review of *Dear Phone*), *Monthly Film Bulletin* (April).

Brown, R. (Review of *The Draughtsman's Contract*) and 'From a View to a Death' (interview with Peter Greenaway and Peter Sainsbury), *Monthly Film Bulletin* (November).

Forbes, J. '*Marienbad* revisited: *The Draughtsman's Contract*', *Sight and Sound* n. 4, v. 51 (autumn).

Greenaway, P. 'The Obscene Animals Enclosure', *Time Out* (17-30 December). Illustrated short story.

Kennedy, H. 'Peter Greenaway: His Rise and "Falls"', *Film Comment* (January / February).

Monthly Film Bulletin. (Reviews of *H is for House*, *Intervals*, *Water Wrackets*, *Windows*), (April).

1983
Auty, C. 'Greenaway's Games', *Stills* (May / June). Interview.

Mars-Jones, A. 'The Film-maker's Contracts', *Sunday Times* (14 August).

Morgan, S. 'Breaking the Contract', *Artforum* v. 23 (November). Interview.

Rayns, T. 'Peter Greenaway', *American Cinematographer* n. 9, v. 64 (September).

1984
Jaehne, K. 'The Draughtsman's Contract: An Interview with Peter Greenaway', *Cineaste* n. 2, v. 13.

Panicelli, I. 'Fritto misto' *Artforum* v. 23 (September).

1985
Millar, G. 'A Zed and two Noughts' *Sight and Sound* v. 55 (winter).

Rayns, T. '"Of Natural History and Mythology Born...": A Guide to the Bestiary', *Monthly Film Bulletin* (December). See also review by Chris Auty.

1986
Irwin, J. 'Peter Greenaway's Contract', *Cinematograph* v. 2 (autumn). Overview of the artist's films to 1981.

Rubenstein, L. '[Formalism makes a comeback in certain avant-garde films]' *Cineaste* n. 2, v. 15.

Schutte, W. 'A Zed and two Noughts', *Artforum* v. 24 (summer).

Sutherland, A. 'Alex Sutherland talks to Director Peter Greenaway about his films', *Screen International* (4-11 January).

1987
Ball, E. 'Art house doldrums', *Afterimage* v. 15 (December).

Clarke, J. 'Architecture and Morality', *Films and Filming* (October).

Ranvaud, D. 'The Belly of an Architect', *Sight and Sound* 56 (summer). Interview.

1988
Elsaesser, T. 'Games of Love and Death, or, An Englishman's Guide to the Galaxy', *Monthly Film Bulletin* (October).

Fusco, C. 'Requiem for an Architect', *Art in America* v. 76 (February).

1989
Romney, J. 'Eating People', *Blitz* n. 82 (October).

Smith, R. 'Greg Colson, Peter Greenaway, Nicolas Rule', *New York Times* (8 December). Review of exhibition at Nicole Klagsbrun Gallery.

1990
Adams, B. (Review of exhibition at Nicole Klagsbrun Gallery), *Art in America* v. 78 (September).

Decter, J. (Review of exhibition at Nicole Klagsbrun Gallery), *Arts Magazine* v. 64 (May).

Enright, R. 'The Rational Extremist: An Interview with Peter Greenaway', *Border Crossings*.

Feo, R. de. 'Fantasy in Crimson', *Art News* n. 89 (March).

Hagen, C. 'Peter Greenaway and the Erotics of form', *Aperture* n. 121 (fall).

Nesbitt, L. E. (Review of exhibition at Nicole Klagsbrun Gallery), *Art Forum* v. 28 (March).

Silverthorne, J. 'The Cook, the Thief, his Wife and her Lover', *Artforum* (April).

Smith, G. 'Food for Thought: Peter Greenaway Interviewed', *Film Comment* n. 3, v. 26.

Wert, W. F. van. 'The Cook, the Thief, his Wife and her Lover', *Film Quarterly* n. 2 v. 44 (winter).

1991
Barker, A. 'A Tale of Two Magicians', *Sight and Sound* (May).

Greenaway, P. 'My Great Advantage over Veronese is that I can make the People Move', *Art Newspaper* n. 9, v. 2 (June).

Greenaway, P. 'Architecture through the Lens', *Blueprint* 79 (July / August).

Pally, M. 'Cinema as the Total Art Form: An Interview with Peter Greenaway', *Cineaste* n. 3, v. 18.

Rodgers, M. 'Prospero's Books – Word and Spectacle: An Interview with Peter Greenaway', *Film Quarterly* n. 2, v. 45 (winter).

Romney, J. 'Prospero's Books', *Sight and Sound* (September).

Tran, D. 'The Book, the Theatre, the Film and Peter Greenaway', *High Performance* v. 14 (winter).

Wills, D. and McHoul, A. 'Zoo-logics: Questions of Analysis in a film by Peter Greenaway' in Hawkes, T. (ed.) *Textual Practice* n. 1, v. 5.

1992
Collins, A. and B. 'Drowning the Text', *Art in America* v. 80 (June).

Greenaway, P. 'Le bruit des nuages', *Connaissance des Arts* n. 489 (November).

Leeuw, R. de. (Review of exhibition at Museum Boymans-Van Beuningen), *Kunst & Museumjournaal* n. 4, v. 3.

Murphy, C. 'Flight and Fancy: an Auteur draws at the Louvre', *Art and Antiques* v. 9 (November).

Piguet, P. 'Le bruit des nuages', *L'Oeil* n. 447 (December).

Turner, J. 'Body Types', *Art News* v. 91 (January).

Yacowar, M. 'Negotiating Culture: Peter Greenaway's *Tempest*', *Queen's Quarterly* n. 33, v. 99 (autumn).

1993
Marin, J. 'Libre opcion a Peter Greenaway en el Louvre', *Goya* n. 232 (January / February).

Tarantino, M. (Review of exhibition at the Louvre), *Artforum* v. 32 (October).

Walsh, J. 'A Shock to the System', *The Independent Magazine* (11 September).

1994
Arnold, K. 'Authoring Chaos', *Museums Journal* v. 94 (March).

Cody, J. 'Interview with Film Maker Peter Greenaway', *Paris New Music Review* (special Dutch issue), (December). Lengthy interview.

Muheim, B. 'Seeing Calvin's City through a Film Director's Eye', *Art Newspaper* v. 5 (April).

Woods, A. 'Peter Greenaway: Part One', *Transcript* n. 1 v. 1 (December). Interview rev. and repr. in Woods (1996).

1995
Arnold, K. 'Peter Greenaway: the film maker in the museum', *Museum News* v. 74 (March / April).

Gras, V. 'Dramatizing the Failure to Jump the Culture/Nature Gap: The Films of Peter Greenaway', *New Literary History* 26.

Rollins, N. 'Greenaway–Gaultier: Old Masters, Fashion Slaves', *Cinema Journal* v. 35 (Fall).

Woods, A. 'Peter Greenaway: Part Two', *Transcript* n. 3, v. 1. Interview rev. and repr. in Woods (1996).

1996
Conrad, P. 'Wizard of Odd', *Independent on Sunday* (20 October).

Elliott, B. and Purdy, A. 'Peter Greenaway and the Technologies of Representation: The Magician, the Surgeon, their Art and its Politics', *Art and Design Profile: Art and Film* v. 11 (July / August).

Gilman, K. L. 'Written on the Body', *Letter Arts Review* n. 4, v. 12.

Matheou, D. 'Through a Lens Darkly', *Architects' Journal* v. 203 (9 May).

Owen, J. 'Romans in the Gloaming', *The Times* (21 June). On the installation at the Piazza del Popolo.

Sight and Sound 'Movie memories' (14–24 May). Writers, film makers and artists respond to questions on cinema.

Wells, P. 'Compare and Contrast: Derek Jarman, Peter Greenaway and Film Art', *Art and Design* v. 11 (July / August).

1997
Bosco, R. 'Fear of flying', *Art Newspaper* v. 8 (March). Review of exhibition at Fundació Miró.

Elliott, B. and Purdy, A. 'An Interview with Peter Greenaway', *Architectural Design* v. 67 (July / August).

Patterson, N. and Katnelson, A. (Lengthy interview with the artist), *On the Make* n. 2, v. 3.

1998
Romney, J. 'What's Opera, Doc?', *The Guardian* (10 July). On *Rosa: A Horse Drama*.

Book published to accompany the exhibition:

Peter Greenaway: Artworks 63–98

Dates of exhibition: 17 October – 6 December 1998

Cornerhouse
70 Oxford Street
Manchester M1 5NH, UK

Exhibition sponsored by Manchester Airport

Front cover detail: **Icarus Falling into Water**, 1997

Back cover: **A Walk Through H: Sandpaper**, 1976–8

Published by Manchester University Press, Oxford Road, Manchester M13 9NR, UK

Distributed exclusively in the USA by St. Martin's Press, Inc., 175 Fifth Avenue, New York, NY 10010, USA
Distributed exclusively in Canada by UBC Press, University of British Columbia, 6344 Memorial Road, Vancouver, BC, Canada V62 1Z2

British Library Cataloguing-in-Publication Data: a catalogue record is available from the British Library.

Library of Congress Cataloging-in-Publication applied for.

Photographic credits.
Photographs of work by Peter Greenaway provided by Mark Fiennes and The VUE (London).

ISBN PAPERBACK: 0 7190 5623 3
ISBN HARDBACK: 0 7190 5624 1

This book is set in Lomba (text) and Opsmarckt (script) from [T26] digital font library, Chicago, USA.
Designed by AW, assisted by DF @ Axis, Manchester, England.
Printed by Craft Print Pte Ltd, Singapore, Singapore.